C000162279

IMAGES
of America

BURGER CHEF

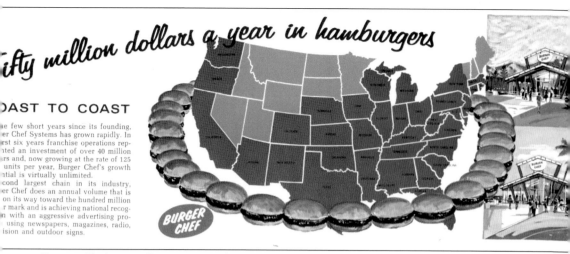

OAST TO COAST

the few short years since its founding,
er Chef Systems has grown rapidly. In
rst six years franchise operations rep-
ted an investment of over 40 million
rs and, now growing at the rate of 125
units per year, Burger Chef's growth
ntial is virtually unlimited.
cond largest chain in its industry,
er Chef does an annual volume that is
on its way toward the hundred million
r mark and is achieving national recog-
n with an aggressive advertising pro-
using newspapers, magazines, radio,
ision and outdoor signs.

Burger Chef was well on its way to becoming a national hamburger chain when this map from about 1965 was produced to highlight the number of states with at least one Burger Chef in operation. Many of the states already had multiple locations by this time. Burger Chef was opening stores at the impressive rate of 125 units per year, and the company had already grown to become the second-largest hamburger chain in the nation. After investing $40 million in its franchise operations for six years, Burger Chef was achieving an annual sales volume of $50 million.

On the cover: A large crowd awaits the opening of the 1,000th Burger Chef in Treasure Island, Florida, on August 9, 1969. This store was built using the new Cosmopolitan II design, commonly referred to as the Cosmo II, which had been introduced during that year. The mansard roof behind the arch was installed to hide stacks and air conditioning units. The Cosmo II had seating for 95 customers. (Courtesy of Frank P. Thomas Jr.)

IMAGES
of America

BURGER CHEF

Scott R. Sanders with a foreword by
founder Frank P. Thomas Jr.

ARCADIA
PUBLISHING

Copyright © 2009 by Scott R. Sanders
ISBN 978-0-7385-6098-4

Published by Arcadia Publishing
Charleston, South Carolina

Printed in the United States of America

Library of Congress Catalog Control Number: 2008943323

For all general information contact Arcadia Publishing at:
Telephone 843-853-2070
Fax 843-853-0044
E-mail sales@arcadiapublishing.com
For customer service and orders:
Toll-Free 1-888-313-2665

Visit us on the Internet at www.arcadiapublishing.com

*To Frank P. Thomas Jr., Donald J. Thomas, and Robert E. Wildman,
whose dedication and innovation made Burger Chef possible.*

CONTENTS

FOREWORD

It has been 50 years since I cofounded Burger Chef and opened the first restaurant in Indianapolis. I was president of Burger Chef for 10 very intense years, consisting of full days, a seven-day workweek, and a lot of travel by airplane. At first, we were operating on a very slim bankroll, and we started with practically nothing. We took very little for ourselves out of the company because we needed to expand the business. All of our efforts were focused on expansion, promotion, and advertising in those days. From those humble beginnings, I am proud to have been a part of building Burger Chef into the second-largest hamburger chain in the country through franchising without public money. Over the years, I have watched the fast-food industry I helped pioneer become a world-wide phenomena. I am so gratified that I was a part of a business that changed the way people look at food.

However, I did not do it alone. My brother-in-law Robert Wildman worked tirelessly, finding new franchisees, securing leases for new locations, and working with store owners. My brother Donald J. Thomas spent a great deal of time working on improving the efficiency of the Sani-Broiler, as well as designing new equipment for our stores. Everyone involved with Burger Chef—the General Equipment Company employees, the franchise holders, the management staff, and the franchisees and their store staffs—was integral to the success of the company.

The story of Burger Chef is really about the birth of the fast-food industry. I think people will find it fascinating to learn that the primary individuals responsible for the origins of fast food—Ray Kroc with McDonald's, David Edgerton and James McLamore with Burger King, and myself with Burger Chef—were all connected through their association with my business, the General Equipment Company. My business partners and I got to know Kroc in the early 1950s when we attended trade shows to sell our soft ice-cream machines, and he was selling Multimixers for Prince Castle. We became associated with Burger King one day in 1956 when Edgerton contacted me to see if we might be able to help him manufacture a hamburger broiler prototype that he had created for his stores. This is what led us to become the manufacturer of the hamburger broiler, and that paved the way for our entry into the hamburger business. Without that phone call, we would have never made a broiler, and Burger Chef would have never existed.

—Frank P. Thomas Jr.

ACKNOWLEDGMENTS

There are a number of individuals whose contributions through interviews, suggestions, and submissions made this book a reality.

First and foremost, I wish to thank Frank P. Thomas Jr. for his guidance, ideas, photograph submissions, information, and encouragement that fostered my interest in the history of Burger Chef, ultimately leading to this book. He graciously and patiently spent many hours answering my questions and earned my endless gratitude. Without his help, this book would not have been possible.

I also wish to thank Donald J. Thomas, who provided information for photographs and proofread my manuscript.

There were several people who agreed to be interviewed for this book. Specifically, I wish to thank Jack Roschman, Tony Grate, Bud Sellick, David Edgerton, Harry Cooler, and Butch Schroeder for taking the time to tell me their stories. The information they supplied was invaluable.

Unless otherwise notes, all images appear courtesy of the author. A number of individuals contributed photographs and supporting information, including Donald J. Thomas Jr., who spent hours scanning rare photographs from his dad's archives; Kyle Brown; Dave and Al Lester; Angela Christopher; Sam Lampson; Paul Browning; the Hazel Park Historical Commission of Hazel Park, Michigan; and the Joe Azer Photograph Collection from the Louise Pettus Archives of Winthrop University.

A special thanks goes to Butch Schroeder of Schroeder's Drive-in in Danville, Illinois, for allowing me to photograph items from his extensive collection of Burger Chef memorabilia.

My friend David Lyons provided me with much-appreciated support and advice from start to finish. I would also like to give a heartfelt thanks to my parents, Richard and Janice Sanders, for their encouragement throughout this project. Finally, to my wife, Jane, thank you for your love, recommendations, and support, and for never tiring of my innumerable conversations about Burger Chef.

INTRODUCTION

Years before Burger Chef flame broiled its first hamburger, cofounder Frank P. Thomas Jr. was the president of the General Equipment Company in Indianapolis, a business that manufactured frozen custard, soft-serve ice cream, and milk shake machines. Thomas's father, Frank P. Thomas Sr., was a gifted carpenter and inventor who started the General Equipment Company to manufacture and sell one of the first frozen custard machines, a device he had designed and built in 1930 during the Depression. Thomas Sr., despite having just a fourth-grade education, possessed a remarkable combination of conceptual ability and mechanical skill. Prior to building the frozen custard machine, he designed and assembled amusement park rides as well as one of the first snow cone machines. Thomas Jr. demonstrated at an early age that he had inherited his father's mechanical aptitude and started working with him as a repairman at General Equipment Company while he was just a teenager. He eventually attended Purdue University and graduated with a degree in mechanical engineering before becoming a partner with his father at General Equipment Company and then its president following his father's retirement. Thomas Jr. followed in his father's footsteps by creating his own food-production machines based on his dad's original designs, including a soft-serve ice cream machine called the Sani-Serv and a shake machine known as the Sani-Shake.

By 1956, the General Equipment Company had become a successful manufacturer and seller of ice-cream and milk shake machines. In the summer of that year, Thomas Jr. received a call from David Edgerton, who was the owner of a small chain of hamburger restaurants in Miami, Florida, called Insta-Burger King. Edgerton was familiar with General Equipment Company because he was using a Sani-Shake machine in one of his stores. He told Thomas Jr. that he had invented a hamburger broiler for his restaurants and wanted to know if General Equipment Company was interested in helping him build more of them. General Equipment Company had never built a broiler, but Thomas Jr. told Edgerton he would take a look at it. They worked together, made some improvements, and General Equipment Company agreed to begin manufacturing the broiler, which was named the Sani-Broiler. The company began supplying Sani-Broilers to Edgerton for his restaurant chain, which he later renamed Burger King. As part of the agreement, Edgerton had the rights to sell the Sani-Broiler in Florida while General Equipment Company manufactured and sold it in all other states.

Now that General Equipment Company was producing all of the major machinery needed to start a restaurant, Thomas Jr. began to consider the idea of opening a demonstration store where he could install his food-service machines and show them in actual operation. In the spring of 1957, he opened his first demonstration store at Little America Amusement Park on Keystone

Avenue in Indianapolis. He called his little walk-up hamburger stand Burger Chef. The first one turned out to be successful, so he opened another demonstration store in Kokomo, Indiana, in June 1957. He eventually opened and operated at least one or two additional Burger Chef demonstration stores in other towns in Indiana.

It was not long before investors began to inquire about the possibility of buying not just the equipment but the entire Burger Chef concept. Thomas Jr. had not intended to franchise Burger Chef; however, as the inquiries kept coming in, he began to seriously consider the possibility. He discussed the idea with his brother Donald J. Thomas and his brother-in-law Robert Wildman, both of whom were his partners and worked with him at General Equipment Company. Frank P. Thomas Jr. and his partners agreed that they would go forward with plans to franchise their concept and create a new division of General Equipment Company called Burger Chef. By doing this, General Equipment Company would no longer have to sell machines exclusively to individual operators. Instead, a complete line of machines could be sold to every franchisee that opened a Burger Chef store. They chose to form a partnership and take jobs that suited each person's particular skills. Frank P. Thomas Jr. became president and principal spokesperson; his brother Donald, who also had a degree in engineering from Purdue University, served as vice president in charge of equipment development. Robert Wildman, who had a degree in business administration from Butler University, became vice president in charge of financing, franchising, and leasing of locations. In addition, the trio brought in a fourth partner, John Wyatt, to help with franchising.

In designing the system for their new company, the four partners decided that the best course of action would be to model their chain after McDonald's. They copied McDonald's self-service format and menu and then brought their ideas for a building design to Indianapolis architect Harry E. Cooler. After listening to their suggestions, Cooler came up with a design for the building, roof arch, and sign, as well as a sketch for the street sign. Cooler's final building concept was an impressive example of modernistic architecture. The buildings were brightly colored in a turquoise, orange, and white motif, but the real impact of the design came from the diamond-shaped roof arch that started at the base of the structure, extended through the ceiling, and jutted above the roof. Equally impressive was the massive steel street sign that was built by the Grate Sign Company of Joliet, Illinois. Tony Grate, owner of the company, created a sign that was truly spectacular. The huge sign, shaped like a kite, reinforced the angles of the roof arch and was a visual magnet, especially at night when it was lit up with glowing neon and dozens of chasing lights.

With the plans for the building and the street sign complete, Burger Chef Systems was officially incorporated in 1958, and the first Burger Chef restaurant opened in the spring of 1958 at 1300 West Sixteenth Street in Indianapolis near the Indiana State Fairgrounds. By 1960, only 73 Burger Chef units were in operation, which Frank P. Thomas Jr. considered to be slow growth. He was convinced that Burger Chef needed a new strategy to compete with McDonald's successfully. Jack Roschman, the state franchise owner in Ohio, suggested that they concentrate on opening stores in smaller towns. Frank P. Thomas Jr. and Robert Wildman agreed, and through this marketing approach, Burger Chef was often the first fast-food chain restaurant in many small towns in America.

The idea to concentrate opening stores in smaller towns proved to be a perceptive one, and from 1961 to 1962, 97 more Burger Chef restaurants were opened, more than the number of stores opened between 1958 and 1960 combined. Going into 1966, Burger Chef had 440 stores operating in the United States. It became both the fastest-growing hamburger chain in the country and the second largest behind industry-leader McDonald's. Frank P. Thomas Jr. decided to concentrate more heavily on promoting his Burger Chef operation, so he renamed the General Equipment Company, calling it Sani-Serv, and made it a division of Burger Chef. Going into 1967, Burger Chef had a total of 584 stores operating in the United States and long-range plans of having 1,000 units open by 1970. During that year, the 274-unit Burger King chain made the announcement that it was being acquired by packaged food giant Pillsbury. Frank P. Thomas Jr.

realized Burger Chef needed a new financial strategy because it lacked the resources to compete with both Burger King and McDonald's, which had gone public in April 1965. A public offering of stock was considered, but the idea was rejected.

General Foods, a packaged foods company even larger than Pillsbury, became interested in acquiring the Burger Chef chain. To Frank P. Thomas Jr. and his partners, it was a solution to their problem. With General Foods's backing and business experience, Burger Chef would have the financial resources and management expertise it needed to compete with McDonald's and Burger King. General Foods made an offer to acquire Burger Chef for about $25 million, which they accepted. In March 1968, General Foods officially announced the acquisition of Burger Chef, which had over 730 restaurants operating in 39 states. Frank P. Thomas Jr. was the only one of the founders to agree to remain with Burger Chef, staying on in a part-time capacity as president.

General Foods launched a vigorous expansion program. By March 1969, there were 932 stores in operation with two units planned for Canada. By the summer of 1969, Burger Chef reached a company milestone when the 1,000th Burger Chef restaurant opened in Treasure Island, Florida. Although expansion continued at a brisk pace, Frank P. Thomas Jr. left Burger Chef in 1970 to pursue other interests. In 1972, General Foods made the stunning announcement that it was taking a $47 million write-off due mostly to difficulties with its Burger Chef division. The overemphasis on expansion had lead to a large number of underperforming stores in poor locations. In an effort to rebuild the company, the number of stores was cut back to about 900 of the best sites. New building designs and logos were tried, together with a more varied menu and an emphasis on product quality. Salad bars were installed in stores in addition to the works bar, which allowed the customer to customize their hamburgers by adding tomatoes, pickles, and other condiments. In 1973, Burger Chef introduced the Fun Meal, becoming the first fast-food chain to offer a kid's meal.

Despite these improvements, Burger Chef continued to lose ground to its major competitors, and its market share continued to shrink. In 1977, General Foods brought in Terrance Collins, a former McDonald's vice president, to be the new president and chief operating officer at Burger Chef. Collins instituted a number of changes to help fix the problems at Burger Chef. He introduced a new logo and building design, overhauled the menu, and added breakfast service. He slowed store growth and changed the advertising to emphasize product, appetite appeal, customer satisfaction, and service.

Collins's changes began to make a difference. Sales increased, and additional changes were made to the menu. Collins left Burger Chef after only a few years and was replaced by John Martin. Martin instituted additional improvements, but by this time, General Foods had already made the decision to call it quits and sell its Burger Chef division. In December 1981, General Foods announced that it had agreed to sell the Burger Chef chain, which consisted of over 650 stores, to Hardee's Food Systems for about $43.5 million. Most Burger Chef stores were converted to a Hardee's, closed, or changed to other restaurants. However, some franchisees were able to operate their restaurants as Burger Chefs for a number of years following the acquisition until the terms of their franchise agreements expired. The last Burger Chef to remain open and operating was the location in Cookeville, Tennessee. When that store's franchise agreement expired in 1996, the last Burger Chef was closed and remodeled into a Pleaser's restaurant.

One

GENERAL EQUIPMENT
BEFORE BURGER CHEF

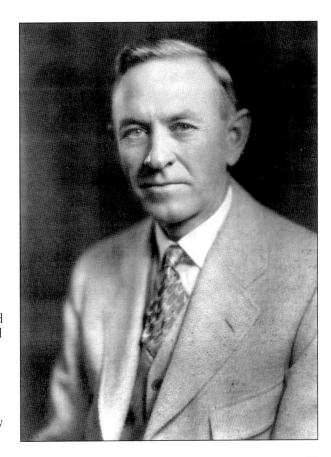

This is a portrait of Frank P. Thomas Sr. at age 52, taken in 1928. In 1930, he designed and built one of the first frozen custard ice-cream machines in the United States. Shortly thereafter, he founded the General Equipment Company in Indianapolis to manufacture his new invention, which he named the Nu-Way frozen custard machine. (Courtesy of Frank P. Thomas Jr.)

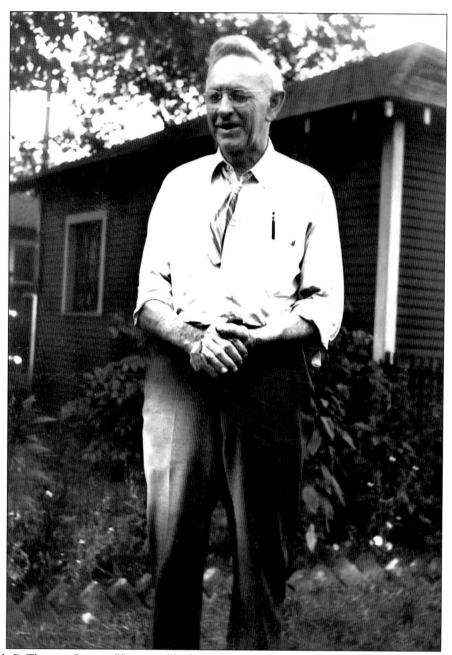

Frank P. Thomas Sr. was 75 years old when this picture was taken in 1951. By this time, he had retired from the General Equipment Company and given his stock in the company to his two sons, Frank P. Thomas Jr. and Donald J. Thomas, and his son-in-law Robert Wildman. General Equipment Company was a successful manufacturer of frozen custard and ice-cream machines in Indianapolis. Thomas Sr. was born in 1876 near Peru, Indiana, and was a carpenter by trade. Despite having just a fourth-grade education and no training in engineering, he was a remarkably innovative inventor. In addition to the frozen custard machine, he designed and built amusement park rides, including a walk-through fun house and some of the first water rides, as well as snow cone machines. (Courtesy of Frank P. Thomas Jr.)

Frank P. Thomas Jr. (center) works on the production line at the General Equipment Company in the spring of 1947. Thomas Jr. attended Purdue University and graduated in 1941 with a degree in mechanical engineering. After serving in World War II, he returned to Indiana and became the co-owner of the General Equipment Company with his father. Following his father's retirement, Thomas Jr. served as company president. Under his guidance, the General Equipment Company went on to become one of the leaders in the restaurant-equipment industry. (Courtesy of Donald Thomas Jr.)

Robert E. Wildman joined the General Equipment Company in 1946 as office manager, where he was put in charge of sales, purchasing, ordering, and payroll. A graduate of Butler University in Indianapolis with a degree in business administration, Wildman eventually became part owner of the General Equipment Company. In this early-1950s photograph, Wildman is standing next to several Sani-Shake machines. (Courtesy of Donald Thomas Jr.)

Donald J. Thomas was only 18 when he posed for this photograph in his uniform while serving in the navy during World War II. After the war, he returned home to Indiana in 1946 to attend Purdue University and earn a degree in mechanical engineering. (Courtesy of Donald Thomas Jr.)

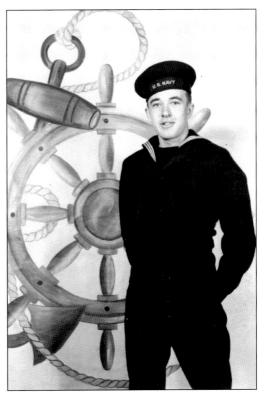

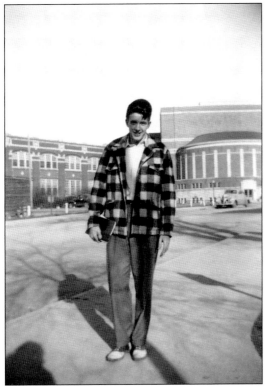

This photograph of Donald J. Thomas was taken in 1946 on the campus of Purdue University. At this time, he worked part-time at the General Equipment Company while taking classes. (Courtesy of Donald Thomas Jr.)

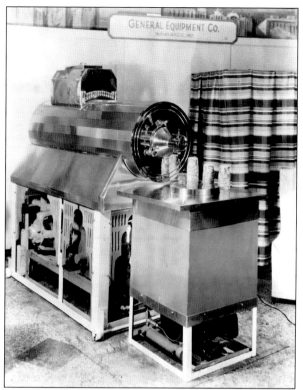

This photograph shows an early model of the EZE-Way frozen custard machine at a trade show around 1950. In 1935, Frank P. Thomas Sr. eliminated the principle of using chipped ice and salt for freezing frozen custard in his Nu-Way machines when he installed compressors and changed the name to EZE-Way because the machines were easier to use. (Courtesy of Donald Thomas Jr.)

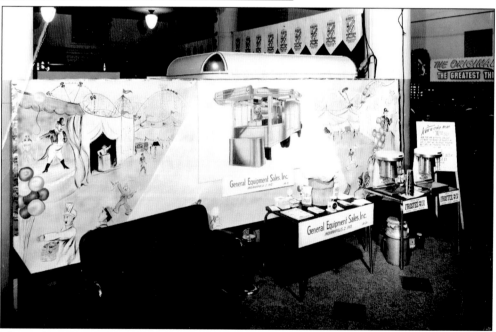

The Midway custom-built trailer was fitted with an EZE-Way frozen custard machine and sold to vendors for use at carnivals and fairs, as evidenced by the illustrations depicting rides and circus tents on the backdrop of this trade show booth in this photograph from about 1950. (Courtesy of Donald Thomas Jr.)

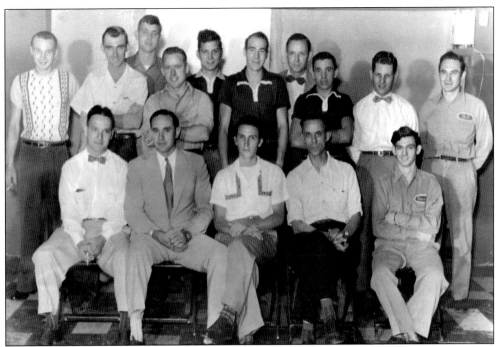

Frank P. Thomas Jr. (first row, second from left) and his staff pose at the General Equipment Company in 1952. After outgrowing the space at their first location, the company built new offices and a larger manufacturing facility in 1950. (Courtesy of Frank P. Thomas Jr.)

Members of the Indianapolis section of the American Society of Refrigerating Engineers (ASRE) stop for a photograph taken during a meeting at the General Equipment Company in June 1953. Standing along the back wall is Frank P. Thomas Jr. (second from left) and Robert Wildman (far right). The photograph on the wall next to Wildman shows an early frozen custard stand built and operated by Frank P. Thomas Sr. (Courtesy of Frank P. Thomas Jr.)

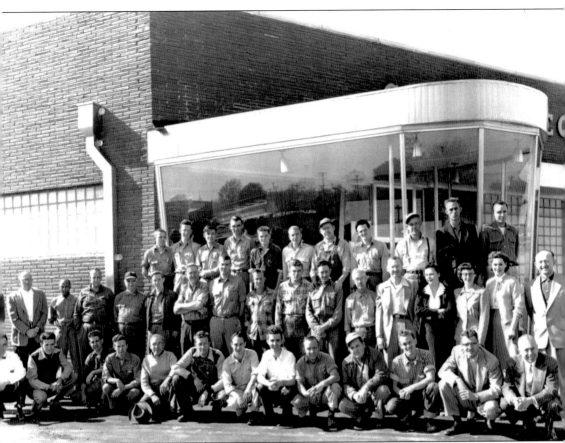

The General Equipment Company staff poses in front of the plant in 1955 at 1348 Stadium Drive in Indianapolis. Frank P. Thomas Jr. is standing in the second row on the far left. His brother Donald is kneeling in the front row, second from the left. Robert Wildman is kneeling in the front row, second from the right. At this time, after graduating from Purdue University in 1950, Donald was working at General Equipment Company full-time, where he managed the shop. (Courtesy of Frank P. Thomas Jr.)

Frank P. Thomas Jr. talks to one of his salesmen at a restaurant equipment trade show booth in Atlantic City, New Jersey, in 1954. As company president, he often represented General Equipment Company and attended similar trade shows in other cities throughout the year. Next to him is a Sani-Shake machine with a mixer mounted on the front. (Courtesy of Frank P. Thomas Jr.)

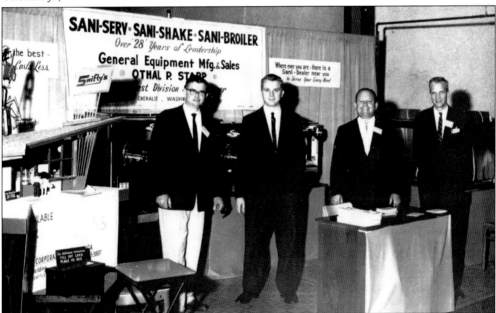

Othal P. Stapp and other General Equipment Company employees are at a trade show about 1956. Stapp was the northwest division distributor for the company. By this time, the company had added the Sani-Broiler to its line of equipment. With the introduction of the Sani-Broiler, the company was manufacturing most of the basic machines necessary for operating a drive-in restaurant. (Courtesy of Donald Thomas Jr.)

START

your own
BUSINESS

EARN BIG PROFITS
WITH THE

Sani-Serv
DIRECT DRAW DAIRY FREEZER

Every man wants to be his own boss. You can take that important step now. If you must realize continuous profits the "minute" your money is invested, and if you have to pay for your business as it grows, the compact Sani-Serv Soft Ice Cream Freezer is for you. It will pay for itself and pay you a liberal living. You'll be really living when you're earning a cozy income, bossing your own business, and serving the crowd with creamy-smooth, soft ice cream, frozen custard, malts, and other frosted delicacies. Write for full information—ask about the pay-as-you-go plan.

GENERAL EQUIPMENT SALES, INC.
902 SOUTH WEST STREET • INDIANAPOLIS, IND

This 1951 advertisement describes the advantages of owning a Sani-Serv soft ice-cream machine. The General Equipment Company frequently listed advertisements such as this one in an effort to sell its machines to potential investors who were interested in starting and operating a soft serve ice-cream stand.

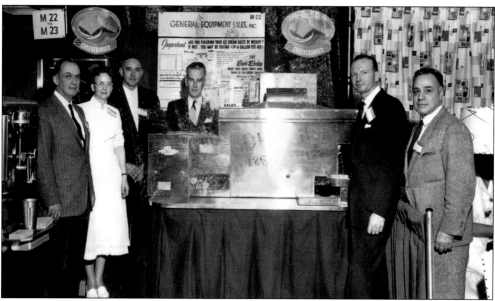

Pictured is a restaurant-equipment trade show at a hotel in New York City in 1956. Frank P. Thomas Jr. is standing at the back of the booth. The new Sani-Broiler is prominently displayed in the middle of the booth, while the Sani-Shake is partially visible to the left. The following year, he made the decision to showcase the operation of both the Sani-Broiler and the Sani-Shake in actual operation when he opened a demonstration store called Burger Chef. (Courtesy of Frank P. Thomas Jr.)

Two

THE EARLY YEARS

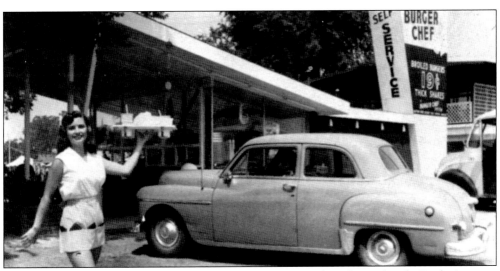

The very first Burger Chef restaurant opened in May 1957 and was located at the Little America Amusement Park in Indianapolis. Frank P. Thomas Jr. built this demonstration store to showcase his restaurant equipment in actual operation, and there were no plans to franchise the concept at this point. Carhops were not used despite the inclusion of the carhop in the photograph.

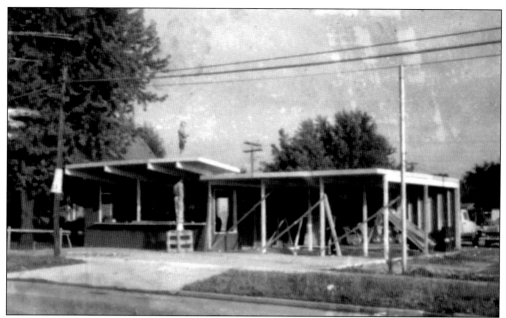

Here is a photograph of the second Burger Chef restaurant under construction in June 1957 in Kokomo. Frank P. Thomas Jr. opened additional demonstration stores in other towns in Indiana during the year. When investors came to him requesting to buy not just the equipment but also the entire concept, he began to consider the idea of franchising Burger Chef. (Courtesy of Frank P. Thomas Jr.)

In 1957, plans were made to create a new division of the General Equipment Company called Burger Chef. Frank P. Thomas Jr., Donald J. Thomas, and Robert Wildman contacted Indianapolis architect Harry E. Cooler regarding their ideas for a restaurant design. Cooler, an acquaintance of Wildman's and a graduate of the University of Illinois School of Architecture, drew this original sketch. Cooler's concept was to create something different and memorable that would stand out. (Courtesy of Paul Browning.)

United States Patent Office

Des. 188,098
Patented June 7, 1960

188,098

DRIVE-IN BUILDING

Frank P. Thomas, Zionsville, Ind., assignor to Burger
Chef Systems, Inc., Indianapolis, Ind., a corporation

Filed Sept. 29, 1958, Ser. No. 52,795

Term of patent 14 years

(Cl. D13—1)

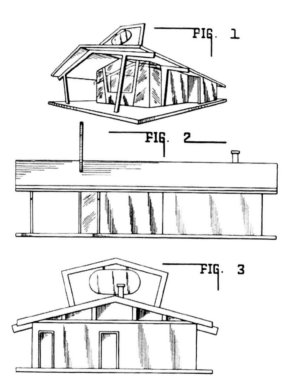

FIG. 1

FIG. 2

FIG. 3

Fig. 1 is a front perspective view of a drive-in building
showing my new design.
Fig. 2 is a side elevation view thereof.
Fig. 3 is a rear elevation view thereof.
The side of the building not shown is substantially
like the side shown.

I claim:
The ornamental design for a drive-in building, as
shown and described.

References Cited in the file of this patent
UNITED STATES PATENTS

D. 155,505 Gustin et al. _____ Oct. 11, 1949
D. 169,055 Carvel _____ Mar. 24, 1953

This is the original design patent submitted to the United States Patent Office by Frank P. Thomas Jr., as designed and drawn by Cooler. The arch on top of the building was intended to give the building a visual impact. Although listed as a drive-in building, hamburger stands like this one were designed to feature self-service windows and were not drive-ins in the traditional sense. (Courtesy of Frank P. Thomas Jr. and the United States Patent Office.)

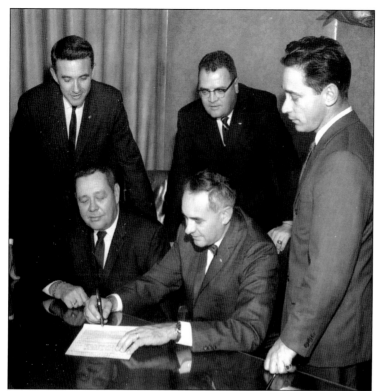

Frank P. Thomas Jr. signs an agreement to have the Grate Sign Company of Joliet, Illinois, build the signs for Burger Chef in 1958 while John Wyatt looks on. Witnessing the signing and standing next to them, from left to right, are Donald J. Thomas, Robert Wildman, and Grate Sign Company owner Tony Grate. Wyatt, who worked for Dairy Delite, was brought in as an additional partner to help with franchising. (Courtesy of Frank P. Thomas Jr.)

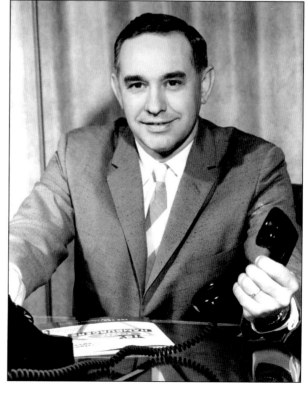

Frank P. Thomas Jr. sits behind his desk at the General Equipment Company in 1958 not long after opening the first Burger Chef of his new restaurant chain located at 1300 West Sixteenth Street across from the Indiana State Fairgrounds. Sitting on the desk in front of him is an original franchise brochure that was sent out to prospective franchisees. (Courtesy of Frank P. Thomas Jr.)

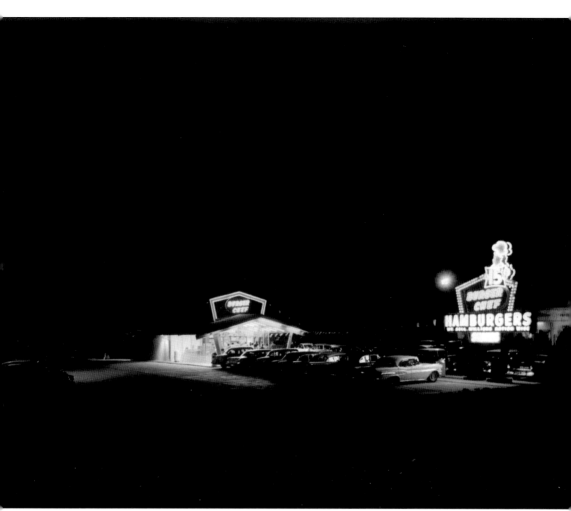

Seen here is a night shot of the Burger Chef located in Lake Charles, Louisiana, which was photographed on August 29, 1959. During the first year of operation in 1958, eight Burger Chef units were opened. By the end of 1959, there were 33 Burger Chef restaurants in operation. (Courtesy of Frank P. Thomas Jr.)

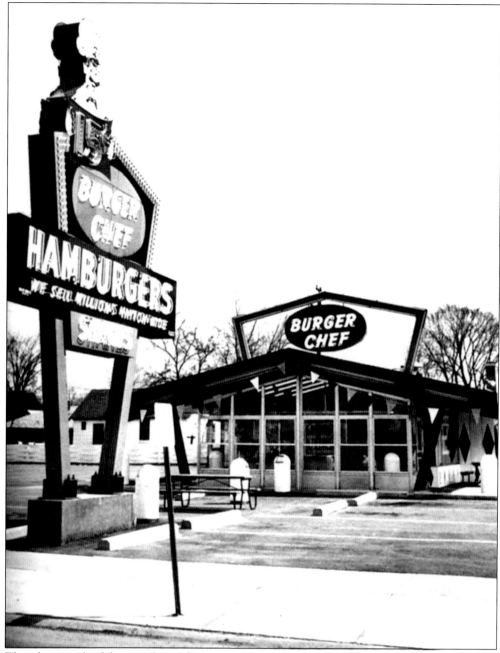

This photograph of the store located at 23240 John R. Street in Hazel Park, Michigan, shows the early-style building with walk-up ordering that was used from the late 1950s to the early 1960s. The glass and metal enclosure at the front of the building was installed during the winter to protect customers from the elements. (Courtesy of the Hazel Park Historical Commission.)

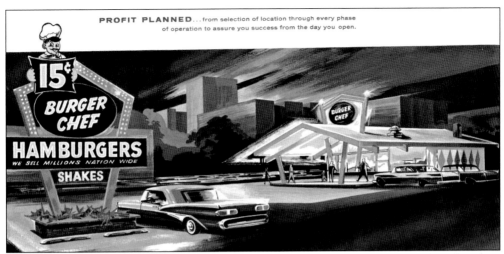

PROFIT PLANNED...from selection of location through every phase of operation to assure you success from the day you open.

Artist's renditions of a Burger Chef location like this one were often included in franchise materials sent out to attract potential store owners.

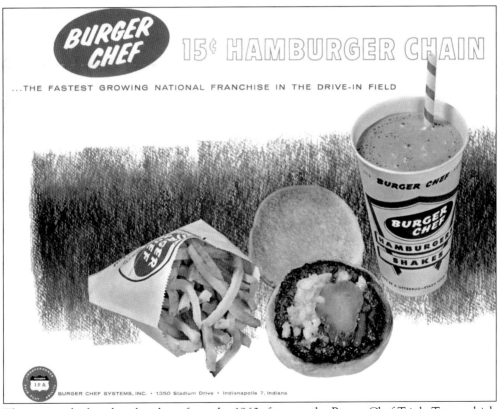

This cover of a franchise brochure from the 1960s features the Burger Chef Triple Treat, which consisted of a hamburger, fries, and a shake. This popular combination was featured in many advertisements and company promotions.

DRIVE-INS ARE NATIONWIDE... *all prospering with this*

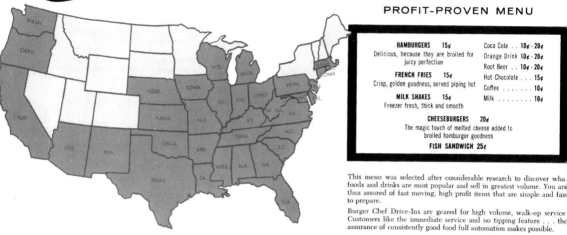

PROFIT-PROVEN MENU

HAMBURGERS 15¢	Coca Cola . . **10¢ - 20¢**
Delicious, because they are broiled for juicy perfection	Orange Drink **10¢ - 20¢**
	Root Beer . . **10¢ - 20¢**
FRENCH FRIES 15¢	Hot Chocolate . . . **15¢**
Crisp, golden goodness, served piping hot	Coffee **10¢**
MILK SHAKES 15¢	Milk **10¢**
Freezer fresh, thick and smooth	

CHEESEBURGERS 20¢
The magic touch of melted cheese added to broiled hamburger goodness
FISH SANDWICH 25¢

This menu was selected after considerable research to discover wha
foods and drinks are most popular and sell in greatest volume. You ar
thus assured of fast moving, high profit items that are simple and fas
to prepare.

Burger Chef Drive-Ins are geared for high volume, walk-up service
Customers like the immediate service and no tipping feature . . . the
assurance of consistently good food full automation makes possible.

By the early 1960s, Burger Chef was successfully expanding and well on its way to becoming a national chain. This map from a 1964 franchise brochure shows the states where Burger Chef had at least one store in operation. Burger Chef had over 300 restaurants at the time and was one of the fastest-growing fast-food chains in the country.

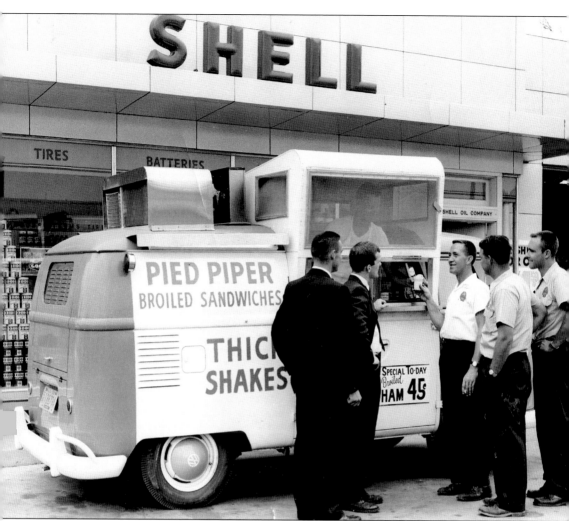

Pied Piper represented an experimental attempt by Burger Chef in 1962 to expand its fast-food concept into other areas. Restaurant equipment built by the General Equipment Company was installed in Volkswagen vans like this one. Food was then prepared in the vans and sold door-to-door to local businesses. (Courtesy of Donald Thomas Jr.)

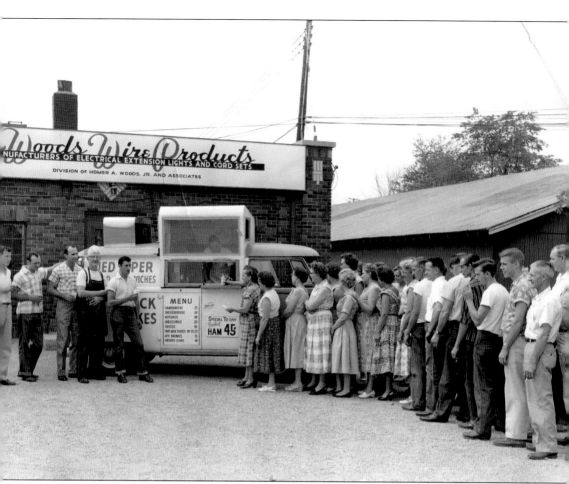

Customers stand in a long line and wait to purchase food from a Pied Piper van parked outside of Woods Wire Products in Indianapolis in the early 1960s. Approximately six Pied Piper vans were built before the idea was abandoned after about a year or two. Despite the sales potential of the idea, the experiment was a failure due primarily to the difficulty in training employees to operate the vans efficiently. (Courtesy of Donald Thomas Jr.)

Three

BURGER CHEF
IN THE 1960S

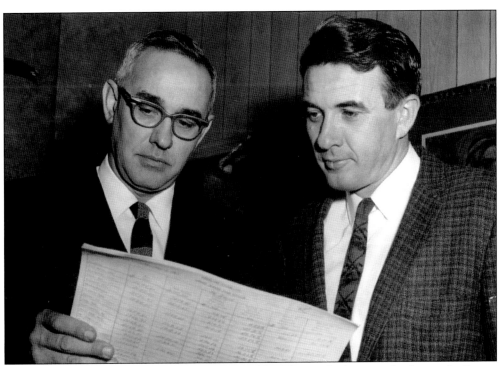

Frank P. Thomas Jr. (left) and his brother Donald J. Thomas look over sales figures for Burger Chef in this photograph taken during the mid-1960s. From 1965 through 1969, the Burger Chef chain experienced rapid growth. By then, Burger Chef was the second-largest hamburger chain in the United States and was giving industry-leader McDonald's some serious competition. (Courtesy of Frank P. Thomas Jr.)

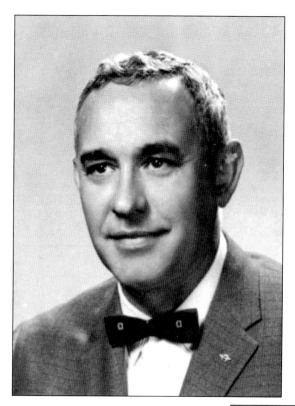

Frank P. Thomas Jr. was cofounder and president of Burger Chef from 1958 to 1969. Through his leadership and innovation, Burger Chef became an enormous success, growing to a chain of over 1,000 restaurants. He was recognized for his achievements in March 1969 when he received the prestigious Silver Plate Award from the Institutional Foodservice Manufacturers Association for his contributions to the restaurant industry.

Robert Wildman was instrumental to the success of the Burger Chef chain. It was primarily through his efforts that Burger Chef was able to expand rapidly through franchising. As a cofounder of Burger Chef, Wildman was originally the secretary-treasurer of the company but soon became executive vice president, a job he held until 1968 when Burger Chef was sold to General Foods.

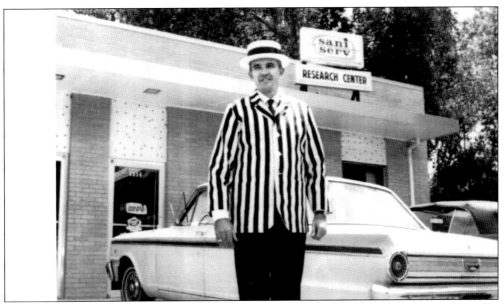

Donald J. Thomas stands outside the Sani-Serv Research Center in St. Louis during the 1960s. As vice president in charge of equipment development, his work was vital to the success of Burger Chef. The reason for the colorful outfit that he is wearing in the photograph is unknown. (Courtesy of Donald Thomas Jr.)

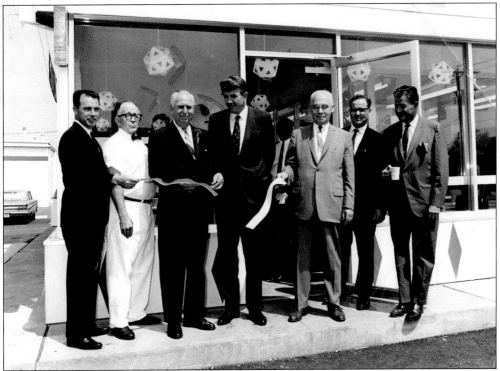

Donald J. Thomas (center) watches as the ribbon is cut on opening day at this unidentified store location in St. Louis, Missouri, during the 1960s. The Burger Chef light globes are hanging prominently in this photograph. (Courtesy of Donald Thomas Jr.)

Frank P. Thomas Jr. learned to fly in order to travel more easily around the country to successfully oversee the operations of his rapidly growing company. As a result, he became an excellent pilot and developed a genuine love for flying. (Courtesy of Donald Thomas Jr.)

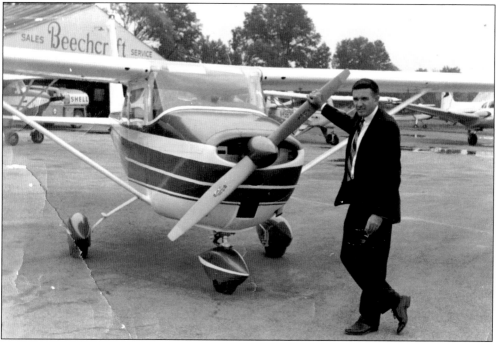

Donald J. Thomas also became an avid pilot. He enjoyed flying and commuted between his home in St. Louis and Burger Chef headquarters in Indianapolis. Here he is pictured with his first plane, a Cessna Skyhawk, at Weiss Airfield in St. Louis. (Courtesy of Donald Thomas Jr.)

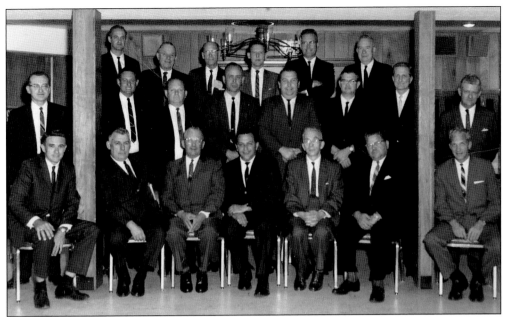

Donald J. Thomas (front row, far left) poses with Sani-Serv distributors in St. Louis. He moved to St. Louis in 1964 to oversee the headquarters of a new General Equipment Company division at 8056 Litzinger Street. The new division was used for equipment development and as a base of operation for Burger Chef expansion. In 1966, the General Equipment Company was renamed Sani-Serv. (Courtesy of Donald Thomas Jr.)

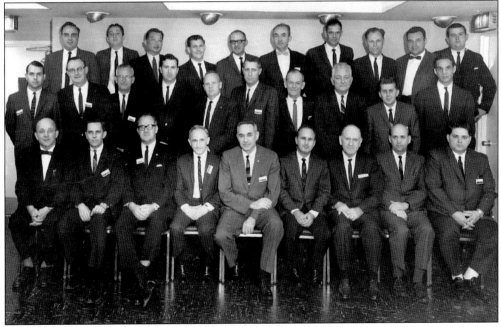

Burger Chef held yearly conventions attended by home office executives, state franchise holders, area representatives, and other supervisors to make plans and discuss the direction of the company. President Frank P. Thomas Jr. (center) is surrounded by three rows of Burger Chef associates in this photograph taken in Chicago. (Courtesy of Frank P. Thomas Jr.)

Frank P. Thomas Jr. (right) is holding a cup of soft-serve ice cream at an industry trade show in Chicago in the 1960s. On the far left is John Holloway, the western division president of Burger Chef. Thomas Jr. and other executives attended shows like this one yearly to promote new equipment built by Sani-Serv, which, by this time, was a division of Burger Chef. (Courtesy of Frank P. Thomas Jr.)

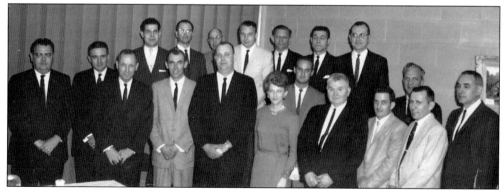

In this undated photograph, Burger Chef employees and executives stop to pose for a photograph during a company meeting. Robert Wildman is on the far left along with Donald J. Thomas, who is standing to his left. Frank P. Thomas Jr. is on the far right. (Courtesy of Donald Thomas Jr.)

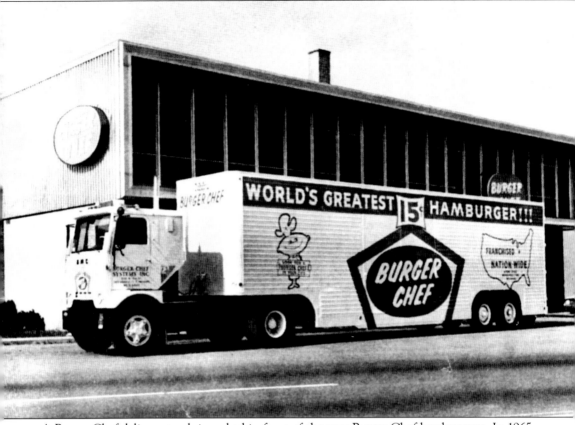

A Burger Chef delivery truck is parked in front of the new Burger Chef headquarters. In 1965, the Burger Chef headquarters was moved to this new building located at 1348 West Sixteenth Street in Indianapolis. Due to the increased expansion of the company, more space was needed for the assembly of store equipment and the Burger Chef corporate offices. The truck was large enough to hold and deliver equipment for three complete store units. Decorated in Burger Chef logos and company colors, the truck also served as a conspicuous advertising tool.

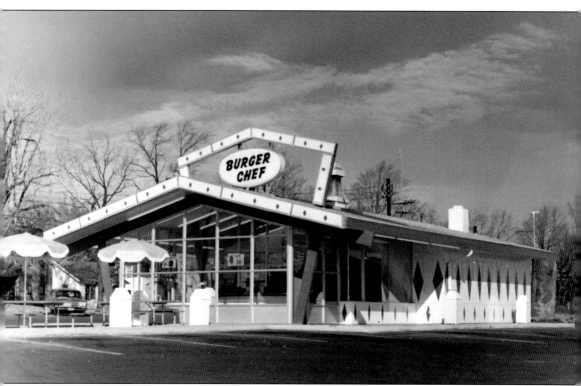

As seen here, some modifications to the original building design had already been implemented by the time this photograph was taken in 1963. The store at this unidentified location is still an early-model building with walk-up ordering, but the lighting on the roof arch is backlit plastic instead of neon tubing. In addition, backlit lighting panels have been added to the front facade. (Courtesy of Kyle Brown.)

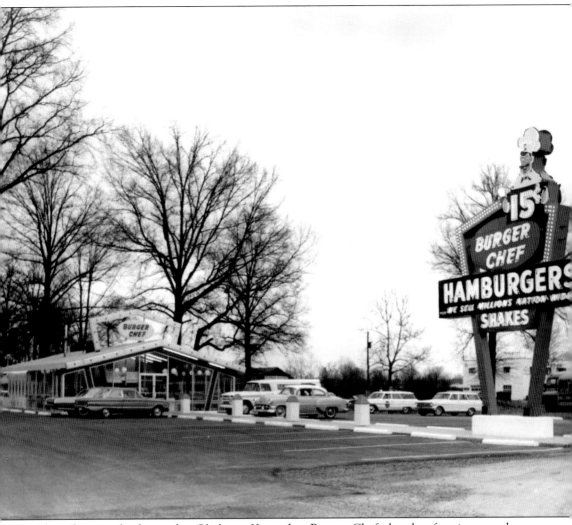

This photograph shows the Okolona, Kentucky, Burger Chef shortly after it opened on December 23, 1964. Located at 8129 Preston Highway, it was store No. 398 and was the second Burger Chef to open in the Louisville area. This store was built using a new, expanded design, featuring a permanent front enclosure and limited indoor seating, which was first used at a store in Indianapolis earlier in 1964. The new design was a move that reflected Burger Chef's objective to change its operation from a drive-in format to sit-down dining. (Courtesy of Kyle Brown.)

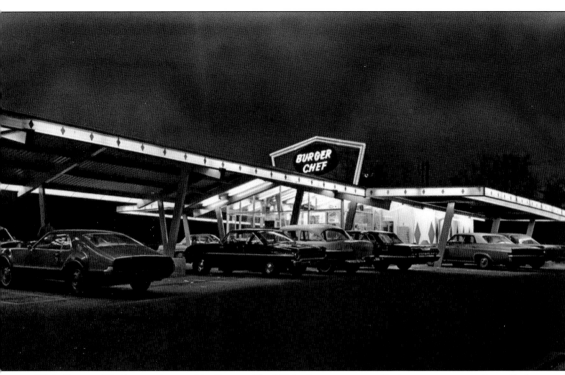

This Burger Chef store, located in Zanesville, Ohio, has an unusually long car canopy installed on the front of the building to protect customers from the weather. It also has the original neon lighting on the sign hanging from the roof arch. The glass and steel enclosure is attached to the storefront of this early walk-up-style building, indicating that this photograph was probably taken during one of the colder months of the year. The models and years of the cars in the parking lot suggest that the photograph was taken around the mid-1960s. Most of the older walk-up buildings like this one were eventually remodeled, using newer designs that increased the square footage and added indoor seating. (Courtesy of Donald Thomas Jr.)

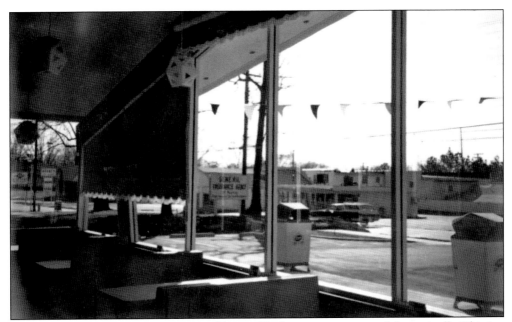

In the late 1960s, the seating capacity of Burger Chef stores was increased dramatically. This is a view from the dining room looking out the front windows toward the parking lot. The unusual icosahedral glass-light globes used in the stores are clearly visible hanging from the ceiling light fixtures in this photograph taken around 1966 at a location in the Louisville, Kentucky, area. (Courtesy of Kyle Brown)

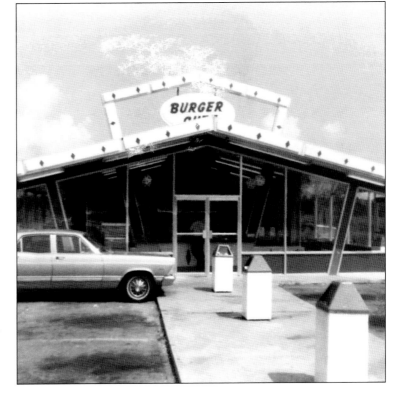

Taken in September 1970, this is a photograph of the store in Moultrie, Georgia. By this time, many older stores like this one were upgraded to newer designs with increased indoor seating. (Courtesy of Al and Dave Lester, from the estate of Raymond E. Lester.)

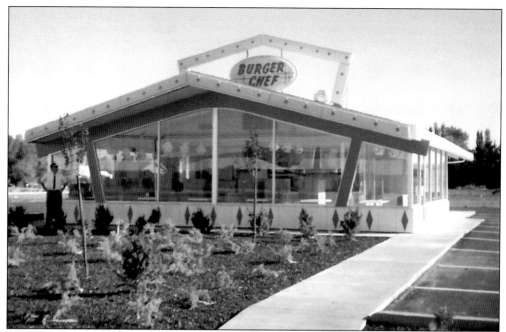

Here is a front shot of the Burger Chef restaurant located at 3511 Sullivant Avenue in Columbus, Ohio, taken not long after it first opened. This picture shows how the white colors and large panes of glass in the design of the building were used to convey an image of quality, cleanliness, and efficiency. (Courtesy of Angela Christopher.)

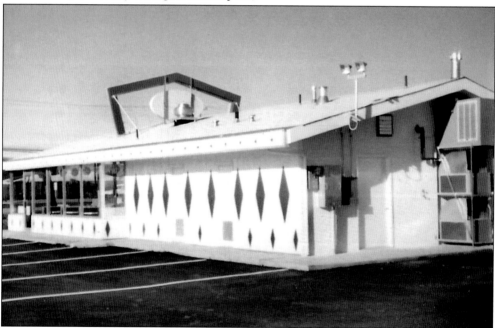

The diamond motif used on the sides of the buildings can be clearly seen in this rear photograph of the Sullivant Avenue location in Columbus, Ohio. The bright orange diamonds were used to reinforce the angles used in both the roof arch and the street sign. (Courtesy of Angela Christopher.)

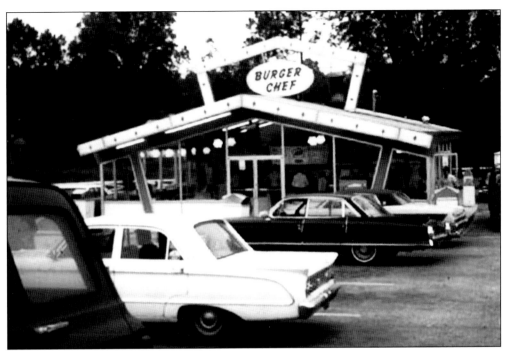

This is another shot of a 1960s-style Burger Chef in Waycross, Georgia, probably taken in the late 1960s or early 1970s. (Courtesy of Al and Dave Lester, from the estate of Raymond E. Lester.)

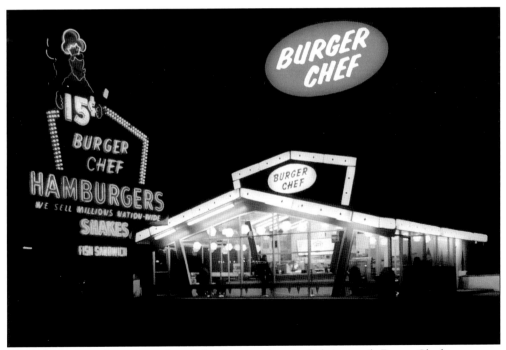

The pulsing neon glowing panels and the gleaming interior lighting made Burger Chef restaurants hard to miss at night. This photograph of an unidentified location was used in franchise materials sent out to potential investors, which explains the inclusion of the logo at the top.

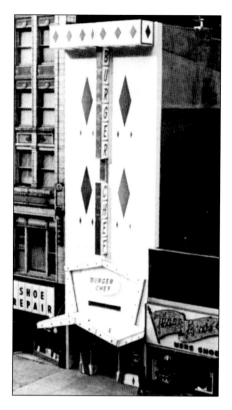

In September 1965, Burger Chef opened its first downtown location at 6 East Washington Street in Indianapolis. The building was famous for being the former location of Craig's candy store. The new store, called the "downtowner," was an experiment to test the viability of a downtown site. The seating capacity of 150 was much larger than a typical Burger Chef restaurant.

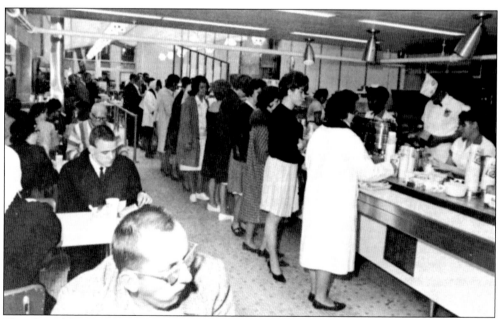

This shot of the inside of the Indianapolis downtowner shows customers moving their trays along a cafeteria-style serving line, which was used to speed up service. In addition to the basic Burger Chef selections, the menu was modified to include soup and desert items as well as doughnuts, sweet rolls, and juice for breakfast.

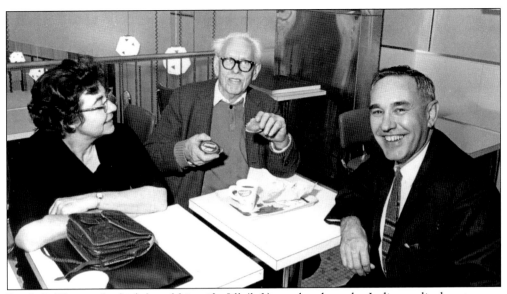

Frank P. Thomas Jr. (right) and his wife, Jill (left), eat lunch at the Indianapolis downtowner along with Indiana artist Elmer E. Taflinger. Taflinger is holding a Burger Chef coin purse. In order to serve the large number of customers at this location efficiently, the Sani-Broiler was revamped, and an improved version was installed that could cook over 2,000 hamburgers in an hour. This was twice as fast as the standard broiler. The downtowner was very successful, and it was not long before plans were made to open similar units in other cities across the country. (Courtesy of Frank P. Thomas Jr.)

According to a Burger Chef newsletter, this sign was a prototype that was tested in the early 1960s and then rejected when it proved to be ineffective. It bears some resemblance to the street sign that was introduced in 1969, so it is possible that some design elements from this sign were integrated into the later style.

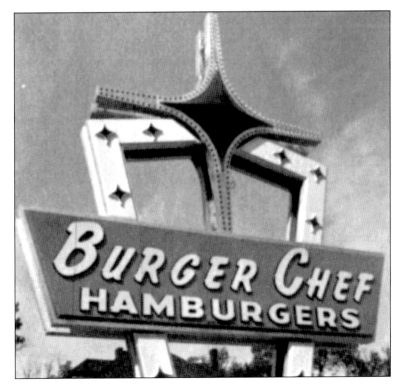

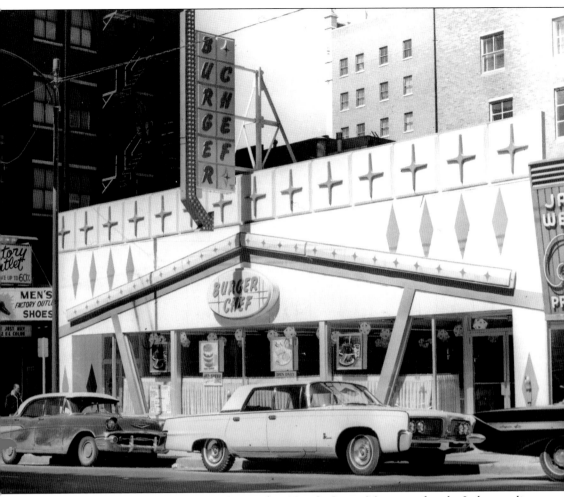

This downtowner Burger Chef opened around 1966 in St. Louis, Missouri, after the Indianapolis location proved to be a success. Several other downtown units were also opened in different cities, including Louisville, Kentucky; Tulsa, Oklahoma; and Norfolk, Virginia. All of the downtowner restaurants did well, and Burger Chef proved that cafeteria style fast-food restaurants could work in a downtown business district. (Courtesy of Frank P. Thomas Jr.)

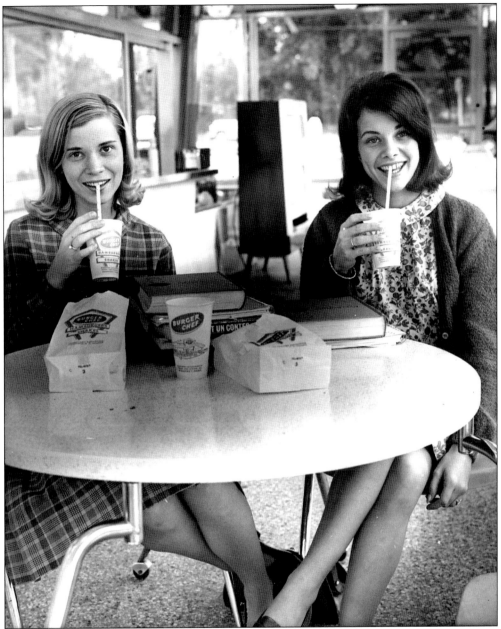

Two smiling college students enjoy a meal at the Burger Chef on Cherry Road near Winthrop University in Rock Hill, South Carolina. The cups and sacks show the Burger Chef logos that were used throughout most of the 1960s. This photograph is undated, but the simple seating accommodations indicate that it could have been taken around the mid-1960s. (Photograph by Joe Azer from the Joe Azer Photograph Collection; courtesy of the Louise Pettus Archives and Special Collections at Winthrop University.)

James W. Brown went to work for Burger Chef in the evenings to make extra money in early 1965. He eventually became a store manager and was given his first store, located at 5109 New Cut Road in Louisville, Kentucky. Brown was 24 years old and had just become a store manager around the time this photograph was taken in 1966. He was eventually promoted to area supervisor. (Courtesy of Kyle Brown.)

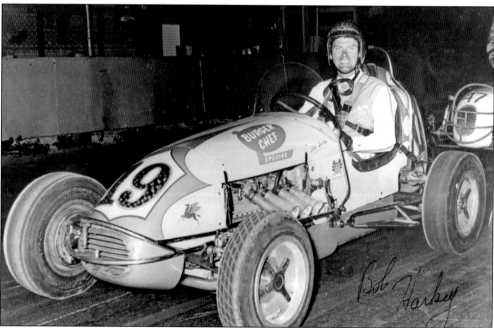

Bob Harkey was a nationally known race car driver who placed eighth in the Indianapolis 500 in 1964. Here he is driving the Burger Chef Special, a race car that Harkey drove on the midget racing circuit as often as three times a week. The car was painted white, orange, and blue to match the official Burger Chef colors. (Courtesy of Kyle Brown.)

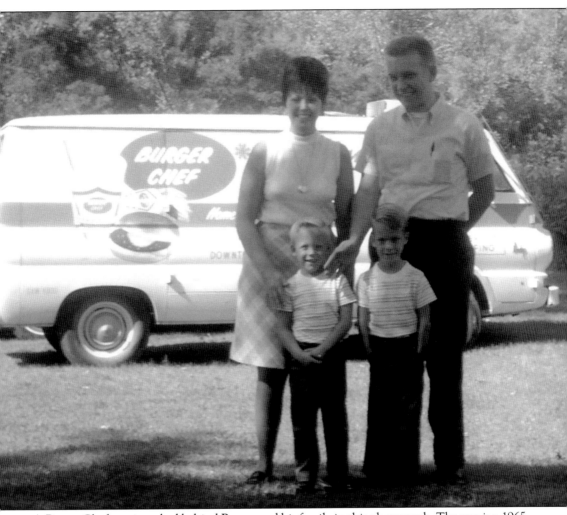

A Burger Chef van is parked behind Brown and his family in this photograph. The van is a 1965 Dodge that was given to Brown to use for traveling to Burger Chef stores after he became an area supervisor. He was responsible for supervising the managers of the stores in Louisville, Kentucky, and southern Indiana. (Courtesy of Kyle Brown.)

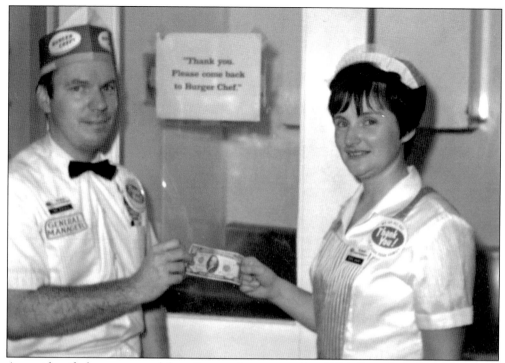

An unidentified manager and front-line worker pose with a $10 bill in this interior shot at a Louisville-area Burger Chef location around 1966. (Courtesy of Kyle Brown.)

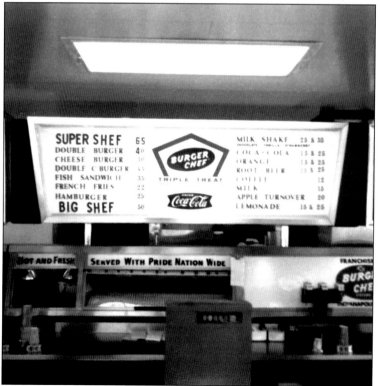

Shown is a 1960s Burger Chef menu board and back counter in a photograph taken in September 1970 at an unidentified location. By the time this photograph was taken, there were new additions to the menu, including the Super Shef and lemonade. (Courtesy of Al and Dave Lester, from the estate of Raymond E. Lester.)

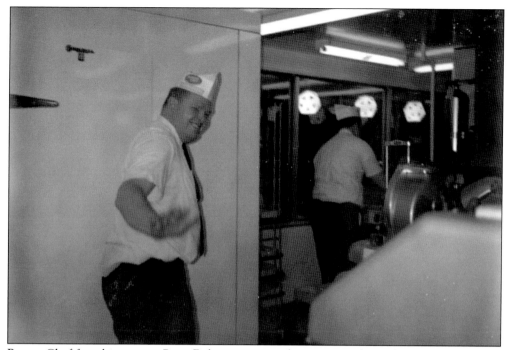

Burger Chef franchise owner Peter Debeer waves at the camera as he makes his way from the preparation room to the broiler at a Louisville-area location in the mid-1960s. (Courtesy of Kyle Brown.)

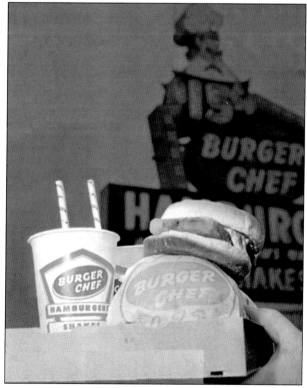

The fish sandwich was added to the menu around 1964. It was created by Ohio state franchise owner Jack Roschman at his Burger Chef store in Dayton. Roschman thought of the idea to take advantage of the sales potential by offering fish on Fridays. The fish sandwich was so successful for Roschman that it was eventually added to store menus company-wide. (Courtesy of Kyle Brown.)

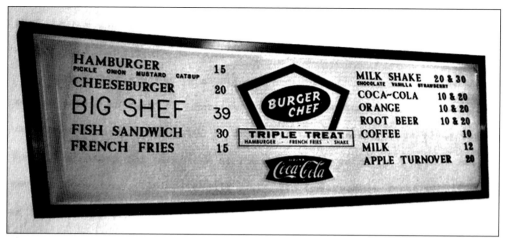

This Burger Chef menu board dates from about 1965. It lists the Big Shef, which was introduced that year, and the fish sandwich for 30¢, which was up from its original price of 25¢ the previous year. The toppings for the hamburger are just below the item listing to let customers know what they could expect on their sandwiches. (Courtesy of Butch Schroeder.)

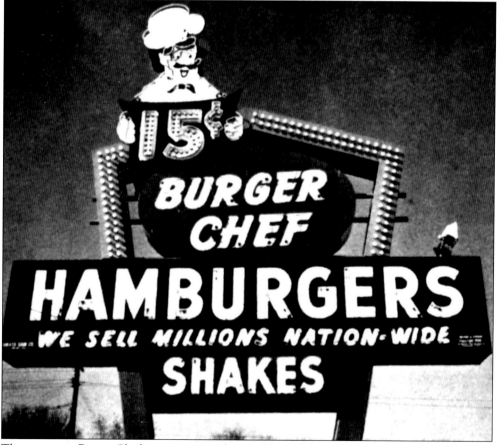

The enormous Burger Chef street sign was designed by architect Harry Cooler and built by sign maker Tony Grate.

Four

Burger Chef under General Foods

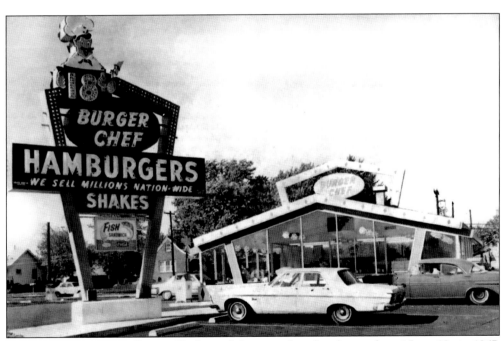

Due to increasing costs, Burger Chef raised the price for a hamburger from 15¢ to 18¢ in 1967. Most franchisees opted to cover the 15¢ price using a plastic overlay with an orange diamond rather than spend the money to have the neon sign altered. This unidentified location was photographed in 1968 just after Burger Chef was acquired by General Foods.

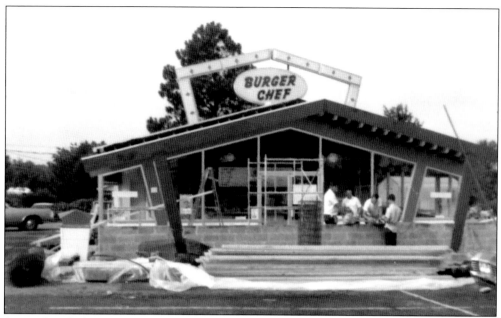

An unidentified Burger Chef location in Georgia built during the 1960s is undergoing remodeling in September 1970. After General Foods acquired Burger Chef in 1968, it began building new stores using the Cosmopolitan II, or Cosmo II, design in about 1969 and then remodeled older stores to match. A front extension was added to older stores like this one to provide space for indoor seating. (Courtesy of Al and Dave Lester, from the estate of Raymond E. Lester.)

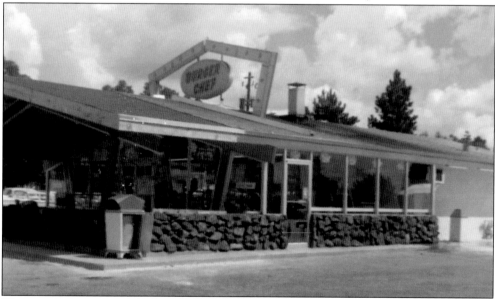

The conversion to a Cosmo II design was nearly complete when the Thomasville, Georgia, Burger Chef was photographed in September 1970. After the front extension was completed, lava rocks were added to the underside in keeping with the design specifications. The Cosmo II upgraded the appearance of older stores and added seating while maintaining some aspects of the original design, such as the roof arch. (Courtesy of Al and Dave Lester from the estate of Raymond E. Lester.)

A worker in a cherry picker basket attached to a boom puts the finishing touches on a new Burger Chef street sign. This sign was first used in about 1969 and was installed in conjunction with the introduction of the new Cosmo II building design. It replaced the original street sign that had been used since 1958. (Courtesy of Paul Browning.)

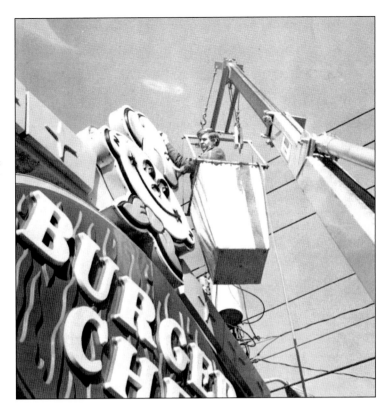

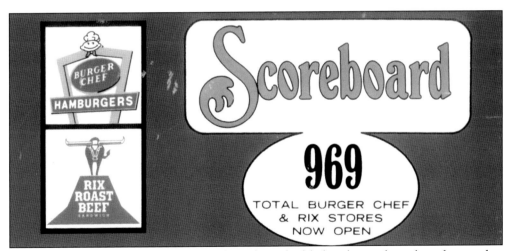

The scoreboard from a 1969 Burger Chef newsletter highlights the total number of stores that were currently in operation. Rix, formerly called Jax, was a chain of roast beef restaurants owned by Burger Chef that was acquired by General Foods during the Burger Chef acquisition. At this time, General Foods was rapidly expanding its Burger Chef operation and was close to opening the 1,000th store. (Courtesy of Paul Browning.)

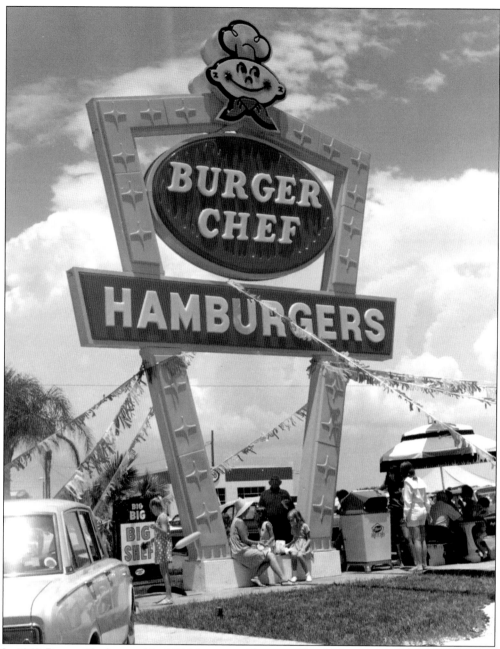

In 1969, Burger Chef opened its 1,000th store in Treasure Island, Florida. This photograph shows the new street sign at that location. The kite shape of the original sign was maintained, but the colors were changed to match the Cosmo II concept, and the chef was moved from the side to the center. (Courtesy of Frank P. Thomas Jr.)

Burger Chef president Frank P. Thomas Jr. accepts a plaque from Charles E. Arnett, president of franchise systems, commemorating the opening of the 1,000th Burger Chef restaurant. Thomas Jr.'s goal was to open 1,000 stores by 1970. General Foods instituted a vigorous expansion plan after acquiring Burger chef in 1968 that enabled that objective to be reached several months earlier than originally planned. (Courtesy of Frank P. Thomas Jr.)

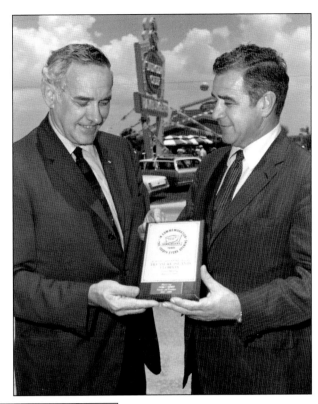

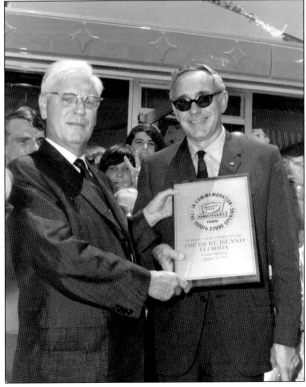

Stewart LaRue, the franchisee and store owner of the 1,000th Burger Chef in Treasure Island, Florida, and Thomas Jr. hold a plaque during store-opening festivities. (Courtesy of Frank P. Thomas Jr.)

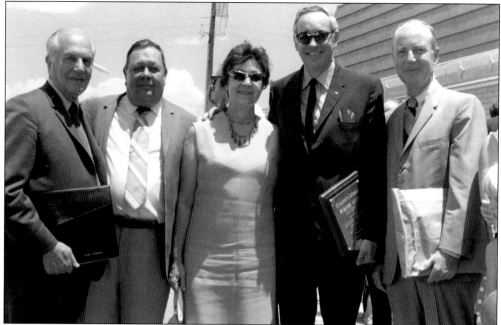

Frank P. Thomas Jr. (center) poses for a picture with his wife, Jill, during the 1,000th store celebration in Treasure Island, Florida. Burger Chef cofounder John Wyatt (second from left) also attended the ceremony. By this time, Wyatt had moved to Texas and was the franchise owner for the southeast section of the state. (Courtesy of Frank P. Thomas Jr.)

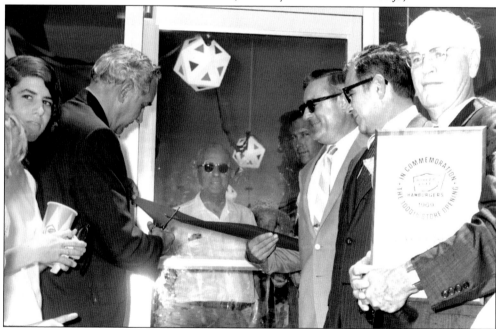

Thomas Jr. cuts the ribbon to open the 1,000th Burger Chef restaurant on August 9, 1969. Holding the ribbon is General Foods vice president George M. Perry. Standing in front of Perry is Charles E. Arnett, president of franchise systems. Stewart LaRue, the store owner, is holding a plaque. (Courtesy of Frank P. Thomas Jr.)

This picture of the street sign at the Thomasville, Georgia, Burger Chef was taken in January 1982. At the time of this photograph, Burger Chef had changed the design of its street signs three times. However, some franchisees chose not to replace their sign, which explains why this older example was still being used over 10 years later. (Courtesy of Al and Dave Lester, from the estate of Raymond E. Lester.)

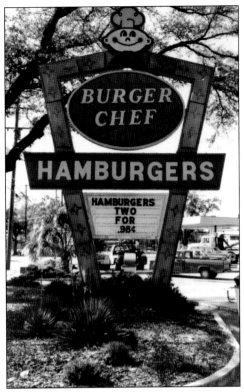

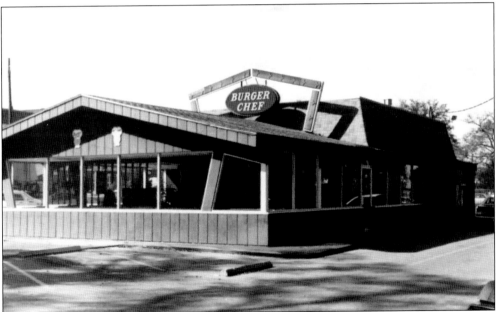

While still a Cosmo II–style building in most respects, the Thomasville, Georgia, Burger Chef bears some later alterations in this January 1982 photograph. The siding installed on the building was an attempt to give it a more subdued look that was typical of the 1970s. Two smiling lollipop chef signs that were used from about 1973 to 1977 are affixed to the front. (Courtesy of Al and Dave Lester, from the estate of Raymond E. Lester.)

The Waycross, Georgia, Burger Chef is a Cosmo II–style building that was never remodeled during the 1970s. This photograph was taken in April 1982. The roof arch and sign were removed at this location. (Courtesy of Al and Dave Lester, from the estate of Raymond E. Lester.)

A rear view of the Waycross, Georgia, restaurant in April 1982 shows an original Burger Chef street sign still in use out front, which indicates that this location dates from the 1960s. (Courtesy of Al and Dave Lester, from the estate of Raymond E. Lester.)

BEFORE

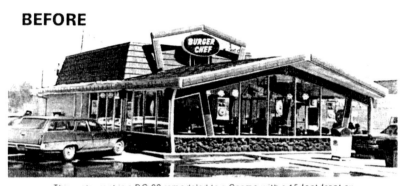

This restaurant is a BC-02 remodeled to a Cosmo with a 15 foot front extension. Prior to modernization it is surveyed for site plan, floor plan with equipment relocations, parking revisions, landscaping, and lot lights. Working drawings are then prepared.

DURING

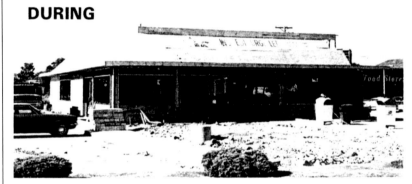

After the preliminary alteration, a 12 foot dining room has been added to the left and the mansard roof frame is taking shape. Parking areas have been relocated and new landscaping is being developed.

AFTER

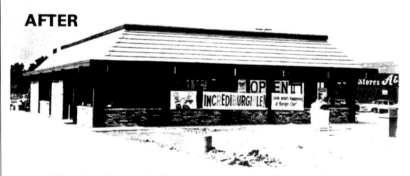

After a few short weeks, the restaurant has a new look, new atmosphere and more than doubled seating capacity. As you can see, signage installation and landscaping are not completed. For a look at the new signage, see the back cover.

This sequence of photographs from 1973 shows the conversion of a Cosmo II Burger Chef into a newer W-II building. The remodeling added a 12-foot extension to the left of the building and a mansard roof. The W-II remodeling doubled the seating capacity. (Courtesy of Paul Browning.)

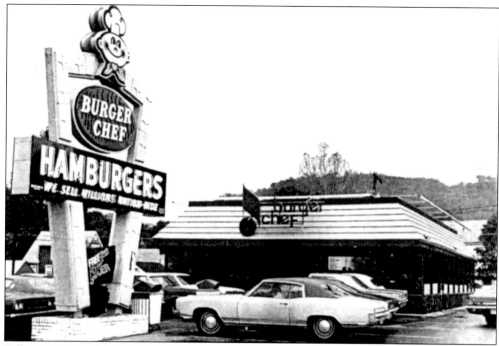

Following a remodeling to a W-II design, this former Cosmo II–style Burger Chef in Charleston, West Virginia, was affixed with the ball-and-flame logo roof sign that was used during the early 1970s. This 1973 photograph shows the newer version of the chef street sign still being used in conjunction with the remodeled exterior and updated logo. (Courtesy of Paul Browning.)

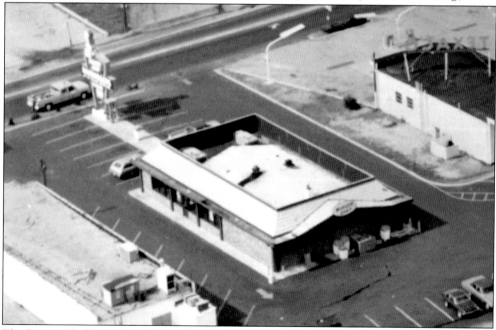

The Burger Chef located on 5511 Valley Station Road in Louisville, Kentucky, was remodeled in about 1975. This aerial shot of the store was taken shortly after the remodel. The original roof of the building is still visible in the center, surrounded by the later addition. (Courtesy of Kyle Brown.)

This is one version of a ball-and-flame logo street sign that was installed in conjunction with the construction of new W-II-style buildings. The logo was only used for about three years before it was changed in 1973. (Courtesy of Paul Browning.)

Remodeled around 1975, the Okolona, Kentucky, Burger Chef is pictured here in the spring of 1982. The roof signage on this store was used by Burger Chef from 1973 to about 1977. (Courtesy of Kyle Brown.)

In 1973, Burger Chef introduced a new logo called the smiling chef to replace the ball-and-flame trademark. New roof signage with the Burger Chef name in lettering was used along with a new street sign known as the smiling chef lollipop design. This photograph is a message from a December 1973 newsletter wishing happy holidays to Burger Chef employees. (Courtesy of Kyle Brown.)

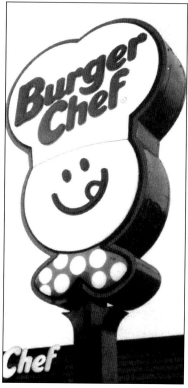

This is a close-up shot of a street sign showing the smiling chef logo. It bears a slight similarity to the chef used during the 1960s. The new-style lettering can be seen inside of the chef's hat. Most of Burger Chef's promotions during the 1970s were targeted toward children, and the style of the new sign also reflected that emphasis.

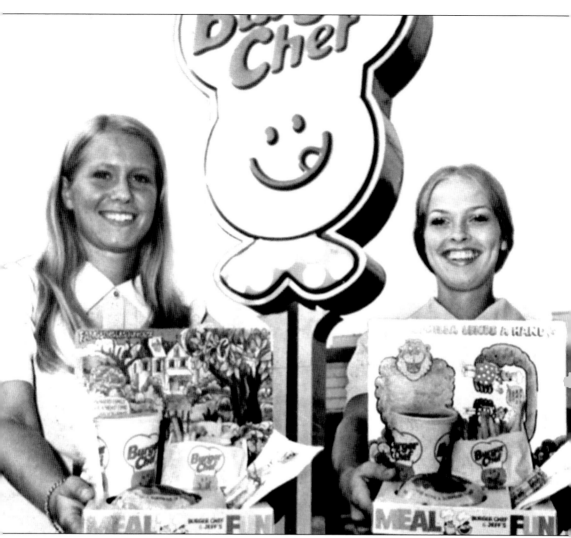

Two smiling waitresses pose with the new Burger Chef Fun Meal in front of a street sign. The Fun Meal was introduced in 1973 and was enormously popular. It was designed for children and consisted of a hamburger, french fries, a small drink, a dessert item, and a toy set into a take-home tray decorated with Burger Chef cartoon characters.

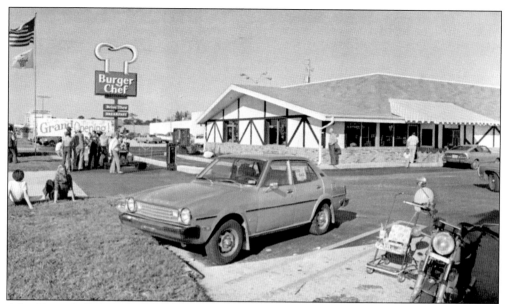

After Terry Collins took over as president of Burger Chef in 1977, the logo was changed again. This photograph shows a street sign with the chef's hat logo that first appeared about 1978. This older Cosmo II–style building was refurbished to match the colors of the new logo. (Courtesy of Kyle Brown.)

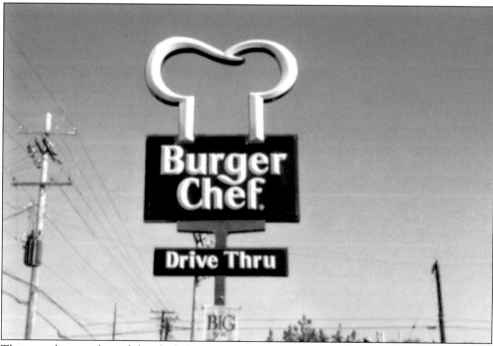

This is a close-up shot of the chef's hat street sign at the store in Okolona, Kentucky, in April 1981. The new sign advertises drive-through service and was installed at this location about 1979. (Courtesy of Kyle Brown.)

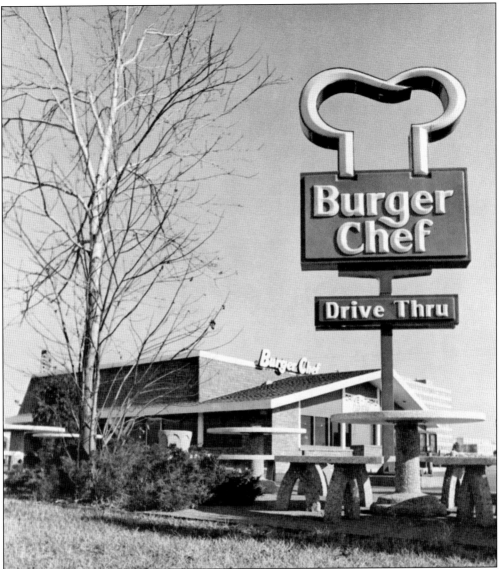

In this photograph of an unidentified location, logos, and designs from different years grace this Burger Chef restaurant. The building is an older Cosmo II building that was remodeled to give it a more contemporary appearance. The roof sign is from the years when the company was still using the smiling chef logo. In front is a street sign with the new chef's hat logo. (Courtesy of Kyle Brown.)

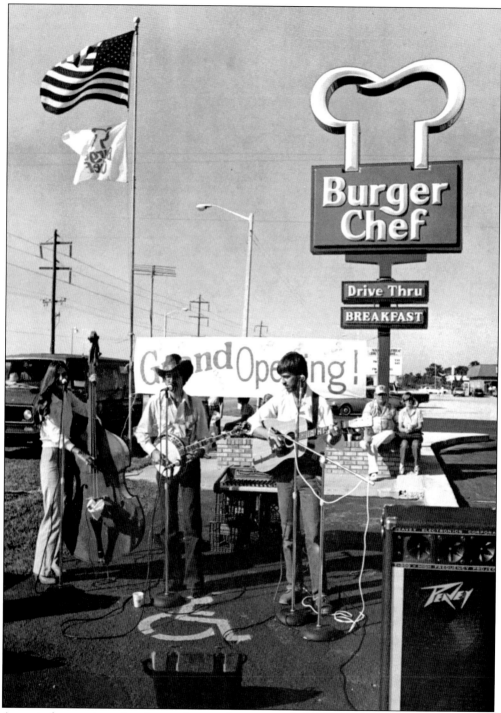

A musical group is performing at the grand opening of an unidentified Burger Chef location around 1978. Burger Chef had begun to offer breakfast service around this time, as indicated by the street sign. (Courtesy of Kyle Brown.)

By eliminating the chef's hat and using only the lettering, Burger Chef created a variation of the street sign that had a fresh, contemporary look. This Burger Chef sign was used at one of the company-owned units in St. Louis. (Courtesy of Al and Dave Lester, from the estate of Raymond E. Lester.)

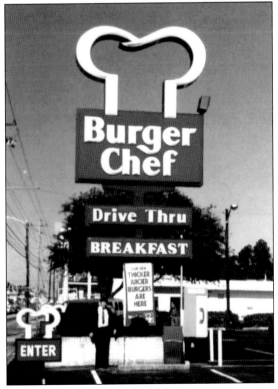

Smaller signs with the chef's hat logo like this one at the Albany, Georgia, Burger Chef were used as entrance markers. This photograph was taken in November 1981. (Courtesy of Al and Dave Lester, from the estate of Raymond E. Lester.)

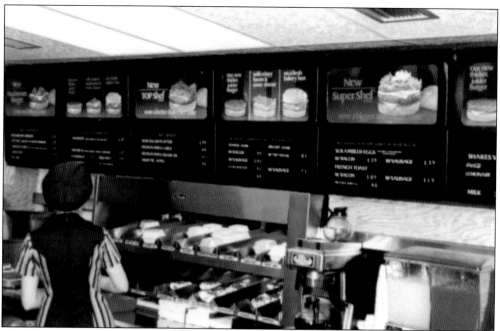

This November 1981 photograph shows the menu board and back counter of the Scottsboro, Alabama, Burger Chef. The new mushroom burger is featured on the translite sign on the menu board along with the Top Shef and the Super Shef. (Courtesy of Al and Dave Lester, from the estate of Raymond E. Lester.)

Here is a side shot of the back counter at an Indianapolis unit photographed in December 1981. (Courtesy of Al and Dave Lester, from the estate of Raymond E. Lester.)

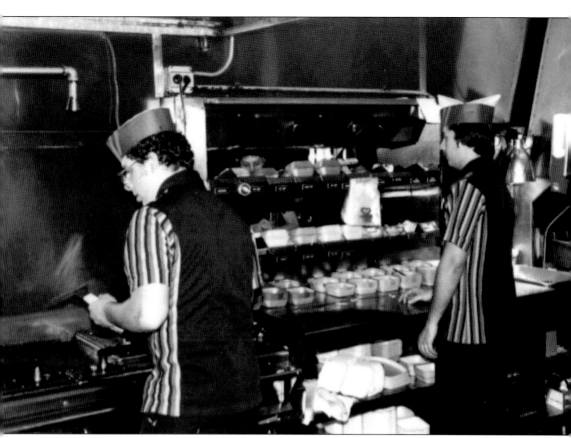

Two unidentified employees are preparing food in this November 1981 shot taken at the Albany, Georgia, Burger Chef. The fact that one of the workers is holding a spatula indicates that this particular restaurant was no longer using a broiler to cook hamburgers. Although some franchisees continued to use broilers, by this time, most stores were using grills to cook their food because of the addition of the breakfast menu. (Courtesy of Al and Dave Lester, from the estate of Raymond E. Lester.)

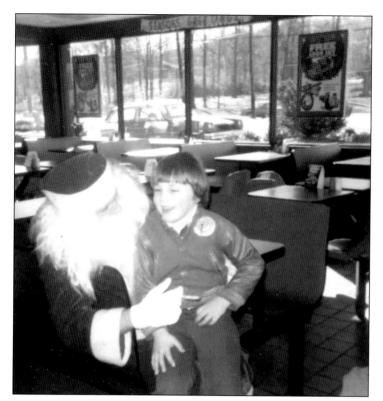

A happy youngster sits on Santa's lap at the Burger Chef located at 5109 New Cut Road in Louisville, Kentucky. Taken in 1978, this interior shot shows what the dining area looked like at the time. (Courtesy of Kyle Brown.)

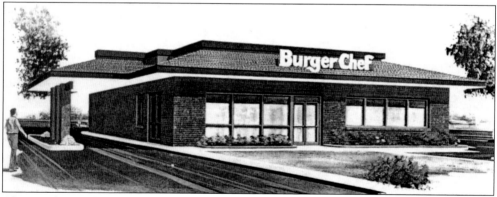

Along with introducing a new street sign in 1978, Burger Chef also came up with a new design for its restaurants. Called the W-III, the new building was designed to have a softer, more contemporary roofline than any of its predecessors. The W-III featured a new, larger interior with 3,710 square feet and a revamped menu board.

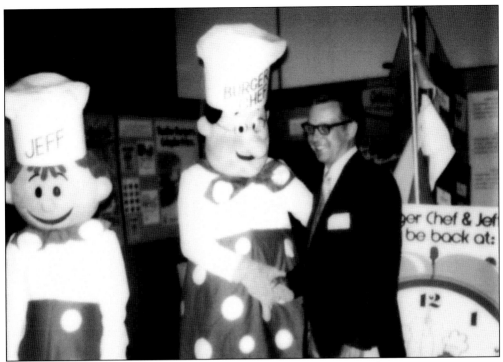

Area manager James W. Brown shakes hands with Burger Chef at a 1974 company convention for supervisors and franchise owners in Orlando, Florida. (Courtesy of Kyle Brown.)

Brown's wife greets Burger Chef at the 1974 convention in Orlando, Florida, as Jeff looks on. (Courtesy of Kyle Brown.)

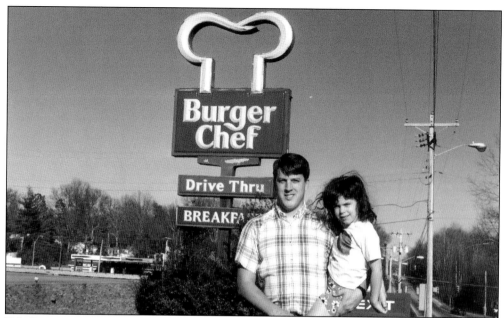

Kyle Brown, son of area manager James W. Brown, stands in front of the Cookeville, Tennessee, Burger Chef street sign while holding his daughter Jacquie in August 1995. This location remained a Burger Chef even after Hardee's bought the restaurant chain in 1982 and closed or converted most of the stores. When it closed in 1996, it was the last Burger Chef restaurant in the United States. (Courtesy of Kyle Brown.)

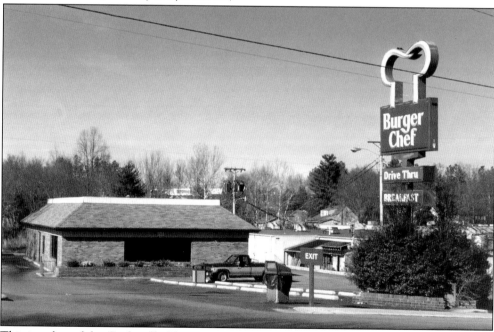

This is a shot of the Cookeville, Tennessee, Burger Chef as it appeared in 1995 one year before it closed. The store appears to be a W-II-style building from the 1970s. After this location closed in 1996, it reopened as a Pleaser's restaurant with basically the same menu as before. (Courtesy of Kyle Brown.)

Five

ADVERTISING

In order to find landowners interested in selling or leasing land for new locations, Burger Chef placed advertisements like this one in magazines. This 1965 advertisement shows a photograph of the Burger Chef training store in Indianapolis. This unique location was a fully operational Burger Chef with offices and classrooms directly behind it, allowing manager trainees to move directly from the classroom to an operating store.

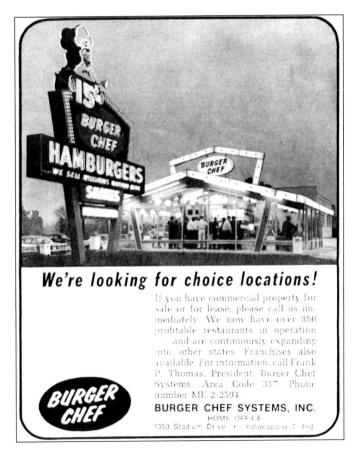

We're looking for choice locations!

If you have commercial property for sale or for lease, please call us immediately. We now have over 350 profitable restaurants in operation . . . and are continuously expanding into other states. Franchises also available. For information, call Frank P. Thomas, President, Burger Chef Systems. Area Code 317. Phone number ME 2-2594.

BURGER CHEF SYSTEMS, INC.
HOME OFFICE
1350 Stadium Drive • Indianapolis 7, Ind.

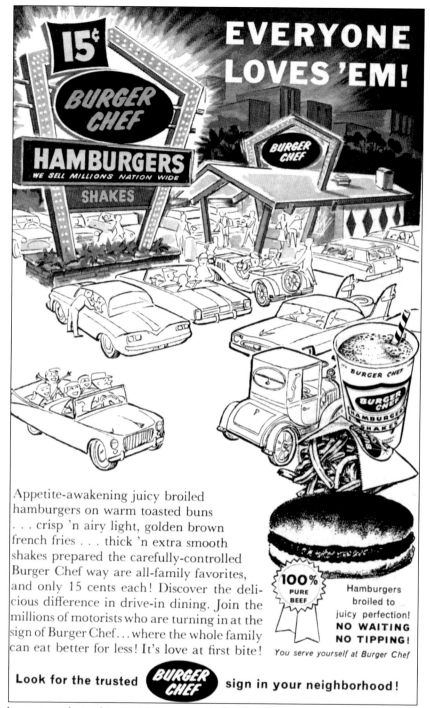

Pictured prominently in this 1961 Burger Chef advertisement is the Triple Treat, a promotion that was started soon after the company was founded in 1958. The "We sell millions nation-wide" slogan on the street sign was a take-off of the advertising gimmick used by McDonald's to highlight the number of hamburgers sold. Conspicuously absent from the sign in this artist's conception is Burger Chef's mascot, the French chef.

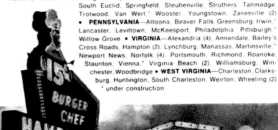

EVERY DAY IS FAMILY DAY

at BURGER CHEF

Where delicious, nutritious food and family fun await you! Like our exclusive, 100% beef, **open-flame broiled** hamburgers—with that "cook-out" flavor you love! Pair 'em up with a sackful of Burger Chef crispy, crunchy french fries! Mm-m—mouth-watering! Ready? Get set. Go Burger Chef!

CHECK THIS LIST FOR THE WORLD'S GREATEST
15¢ HAMBURGER NEAREST YOU! OVER 400 RESTAURANTS NATIONWIDE

INDIANA—Anderson (2), Bloomington, Columbus, Evansville,* Fort Wayne (2), Gary, Greenfield,* Indianapolis (15), Kokomo, Lafayette (2), Michigan City, Muncie, New Albany, New Castle, Plainfield,* Richmond,* South Bend (2), Speedway,* Terre Haute (2), Valparaiso, West Lafayette • **MICHIGAN**—Adrian,* Dearborn, Detroit, Flint, Garden City, Grand Rapids (2), Hazel Park, Jackson (3), Kalamazoo (2), Lincoln Park, Livonia (3), Mt. Clemens, Muskegon, Muskegon Heights, Plymouth, Pontiac, Port Huron, St. Clair Shores, Ypsilanti • **NEW JERSEY**—Bridgeton, Burlington, Freehold, Keyport,* Maple Shade,* Northfield, Oakhurst, Raritan Township,* Toms River, Wayne • **OHIO**—Akron (2), Alliance, Ashland, Bowling Green, Cambridge, Canton, Chillicothe, Cleveland (2), Columbus (4), Cuyahoga Falls,* Dayton (7), Delaware, Dover, Evendale,* Fairborn, Findlay, Fostoria, Fremont, Ironton, Lancaster, Lima,* Mansfield,* Marion, Massillon, Mentor, Miamisburg, Milford, Mt. Vernon, Newark, Niles, Parma Heights, Piqua, Portsmouth (2), Reading,* Salem, Sandusky, South Euclid, Springfield, Steubenville, Struthers, Tallmadge, Trotwood, Van Wert,* Wooster, Youngstown, Zanesville (2) • **PENNSYLVANIA**—Altoona, Beaver Falls, Greensburg, Irwin,* Lancaster, Levittown, McKeesport, Philadelphia, Pittsburgh,* Willow Grove • **VIRGINIA**—Alexandria (4), Annandale, Bailey's Cross Roads, Hampton (2), Lynchburg, Manassas, Martinsville,* Newport News, Norfolk (4), Portsmouth, Richmond, Roanoke, Staunton, Vienna,* Virginia Beach (2), Williamsburg, Winchester, Woodbridge • **WEST VIRGINIA**—Charleston, Clarksburg, Huntington, South Charleston, Weirton, Wheeling (2)
* under construction

This is a later advertisement from 1965 that lists many of the over 400 Burger Chef locations in operation at the time. The emphasis in this advertisement is on the family, as evidenced by the "Every day is family day" slogan and the images of happy kids and their parents. The cookout flavor of the broiled hamburgers is also highlighted.

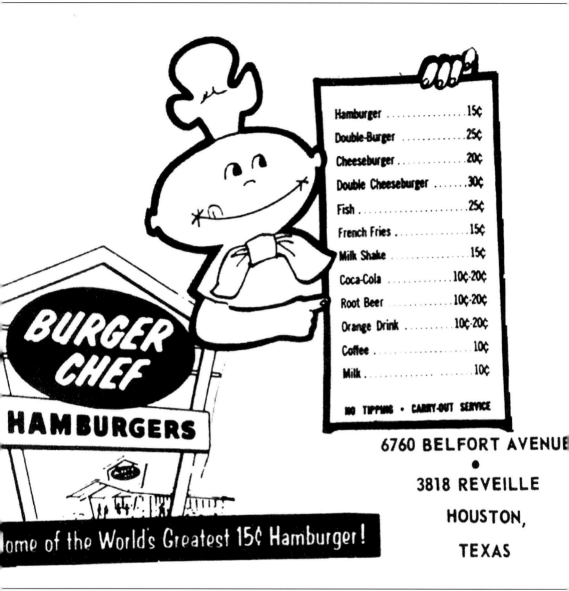

This Burger Chef advertisement from a Houston, Texas, church directory is probably from about 1964 because it lists the fish sandwich but does not include the Big Shef, which was added to the menu in 1965. The double hamburger and cheeseburger were recent additions to the menu. They were added because McDonald's had just begun to offer larger hamburgers, and Burger Chef wanted to keep pace with its biggest competitor. As the advertisement indicates, Houston had two Burger Chef stores in operation at the time. The Bellfort Avenue location opened first around 1964, and the Reveille store was added shortly after. Eventually, five Burger Chef restaurants were opened in the Houston area in the 1960s. They were all closed in the early 1970s. (Courtesy of Sam Lampson.)

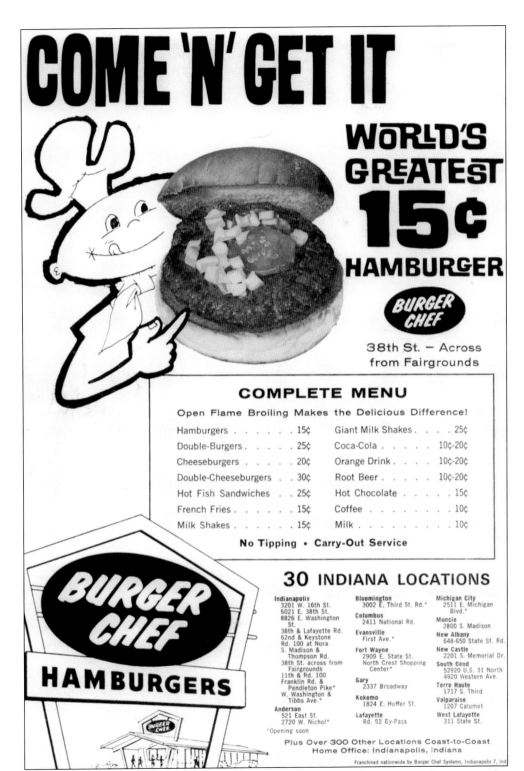

Indiana had 30 Burger Chefs in operation, according to this advertisement that appeared in 1964. Not surprisingly, 11 of the locations were in Indianapolis, where the company was based.

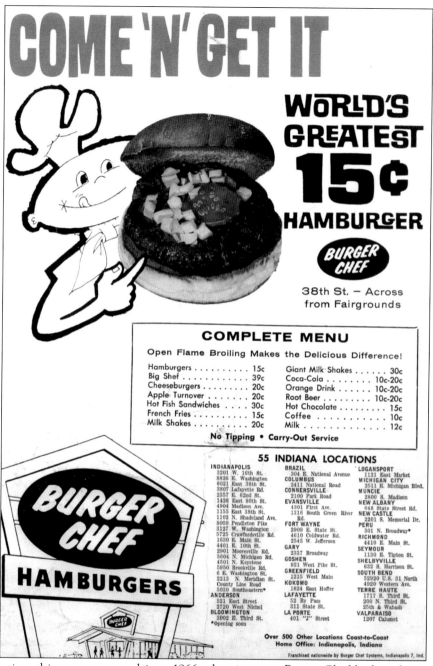

COME 'N' GET IT

WORLD'S GREATEST 15¢ HAMBURGER

BURGER CHEF

38th St. — Across from Fairgrounds

COMPLETE MENU

Open Flame Broiling Makes the Delicious Difference!

Hamburgers	15c	Giant Milk Shakes	30c
Big Shef	39c	Coca-Cola	10c-20c
Cheeseburgers	20c	Orange Drink	10c-20c
Apple Turnover	20c	Root Beer	10c-20c
Hot Fish Sandwiches	30c	Hot Chocolate	15c
French Fries	15c	Coffee	10c
Milk Shakes	20c	Milk	12c

No Tipping • Carry-Out Service

55 INDIANA LOCATIONS

INDIANAPOLIS
3201 W. 16th St.
8826 E. Washington
6021 East 38th St.
3807 Lafayette Rd.
2357 E. 62nd St.
1426 East 86th St.
4904 Madison Ave.
1155 East 38th St.
1102 N. Shadeland Ave.
8009 Pendleton Pike
3127 W. Washington
5725 Crawfordsville Rd.
1630 E. Main St.
4401 E. 10th St.
2901 Mooresville Rd.
5604 N. Michigan Rd.
4501 N. Keystone
5950 Brookville Rd.
6 E. Washington St.
2213 N. Meridian St.
5030 Southeastern*
ANDERSON
521 East Street
2720 West Nichol
BLOOMINGTON
3002 E. Third St.
*Opening soon

BRAZIL
304 E. National Avenue
COLUMBUS
2411 National Road
CONNERSVILLE
2100 Park Road
EVANSVILLE
4301 First Ave.
1316 South Green River Rd.
FORT WAYNE
2909 E. State St.
4610 Coldwater Rd.
2545 W. Jefferson
GARY
2337 Broadway
GOSHEN
921 West Pike St.
GREENFIELD
1215 West Main
KOKOMO
1824 East Hoffer
LAFAYETTE
52 By Pass
311 State St.
LA PORTE
401 "J" Street

LOGANSPORT
1121 East Market
MICHIGAN CITY
2511 E. Michigan Blvd.
MUNCIE
2800 S. Madison
NEW ALBANY
648 State Street Rd.
NEW CASTLE
2201 S. Memorial Dr.
PERU
301 N. Broadway*
RICHMOND
4410 E. Main St.
SEYMOUR
1130 E. Tipton St.
SHELBYVILLE
632 S. Harrison St.
SOUTH BEND
52920 U.S. 31 North
TERRE HAUTE
1717 S. Third St.
200 N. Third St.
25th & Wabash
VALPARAISO
1207 Calumet

Over 500 Other Locations Coast-to-Coast
Home Office: Indianapolis, Indiana

Franchised nationwide by Burger Chef Systems, Indianapolis 7, Ind.

BURGER CHEF HAMBURGERS

By the time this menu appeared in a 1966 advertisement, Burger Chef had made two new additions: the Big Shef, which first appeared in 1965, and the apple turnover. The Big Shef was a double-decker hamburger that was created by Ohio state franchise owner Jack Roschman. Roschman based the Big Shef on the popular Big Boy hamburger featured at Big Boy restaurants. The apple turnover was added around 1966 and was Burger Chef's first dessert item. In addition, the prices for several menu items show increases. A fish sandwich, which was originally 25¢, was increased to 30¢. The price for the regular and giant milk shake was increased by 5¢. Milk was also raised in price from 10¢ to 12¢.

This advertisement from about 1966 is from a kit that was sent out to store owners. It emphasizes that because Burger Chef uses open-flame cooking, its hamburgers taste like they were cooked at home. Burger Chef's original "World's Greatest Hamburger" slogan is still being used in this advertisement. (Courtesy of Butch Schroeder.)

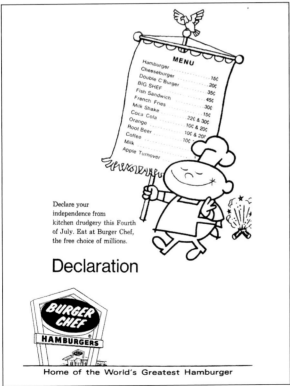

Advertisements like this one were used around certain holidays to encourage families to get out of the house and eat at Burger Chef. In keeping with the Fourth of July theme, this advertisement from about 1966 states that eating at Burger Chef will give "independence" from the chore of cooking in the kitchen. (Courtesy of Butch Schroeder.)

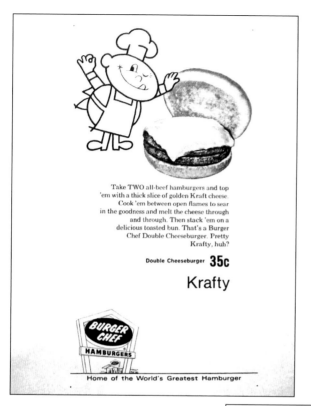

The fact that Burger Chef made its double cheeseburgers with Kraft cheese, a well-known brand, is stressed in this advertisement. The Kraft brand name is also used for the pun that appears at the end of the advertisement copy. (Courtesy of Butch Schroeder.)

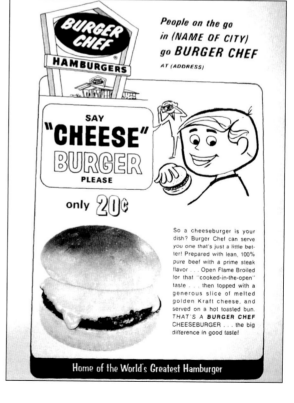

Burger Chef's cheeseburger was a popular seller. In addition to showing a photograph of a freshly cooked burger with melting cheese, this advertisement also highlighted ingredients and flame broiling in an effort to convince the customer to visit Burger Chef and order a cheeseburger. (Courtesy of Butch Schroeder.)

A special tartar sauce was used on the fish sandwiches offered at Burger Chef. The fish sandwich was a popular menu item that gave customers an option other than hamburgers. (Courtesy of Butch Schroeder.)

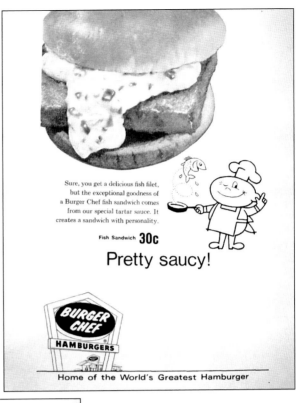

Sure, you get a delicious fish filet, but the exceptional goodness of a Burger Chef fish sandwich comes from our special tartar sauce. It creates a sandwich with personality.

Fish Sandwich **30¢**

Pretty saucy!

Home of the World's Greatest Hamburger

Have a happy Labor Day. Wrap up the summer season with a tasty carry-out meal from Burger Chef. There's no work to it at all . . . and for us, it's a labor of love.

Labor(less) Day

Home of the World's Greatest Hamburger

This is another holiday-related advertisement that emphasizes the benefits of getting a carry-out meal at Burger Chef. (Courtesy of Butch Schroeder.)

Burger Chef emphasized the name brands it used in this 1960s advertisement. (Courtesy of Butch Schroeder.)

During the summer, Burger Chef used advertisements like this one showing its mascot diving into an icy-cold drink. (Courtesy of Butch Schroeder.)

This is another summer advertisement that shows the three flavors of drinks offered at Burger Chef. (Courtesy of Butch Schroeder.)

When the kids went back to school, Burger Chef gave away free pencils. (Courtesy of Butch Schroeder.)

Burger Chef used a sport-related theme in this 1972 advertisement for the Burger Chef located at the Tilton Shopping Center in Northfield, New Jersey.

The thick shakes sold at Burger Chef were made using the Sani-Shake machine manufactured by the General Equipment Company. (Courtesy of Butch Schroeder.)

"Meal Deal" was another name used by Burger Chef to describe the Triple Treat. (Courtesy of Butch Schroeder.)

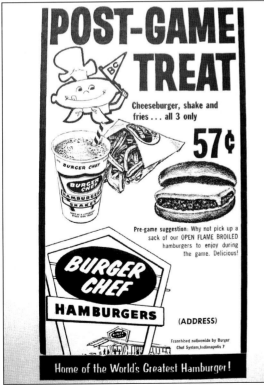

This is another sports-related advertisement that shows the price for a Triple Treat. (Courtesy of Butch Schroeder.)

In 1967, Burger Chef raised the price of its hamburgers to 18¢, so it had to stop using the original "World's Greatest 15¢ Hamburger" slogan. It was shortened to "World's Greatest Hamburger" and then gradually phased out. The slogan "People on the Go . . . Go Burger Chef" first appeared in 1967. (Courtesy of Butch Schroeder.)

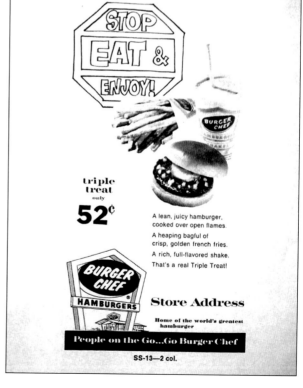

The older "World's Greatest Hamburger" saying was still used for this 1960s advertisement but reduced in size to emphasize the newer "People on the Go . . . Go Burger Chef" slogan. This advertisement encourages the customer to "Stop, Eat & Enjoy" a meal at Burger Chef. (Courtesy of Butch Schroeder.)

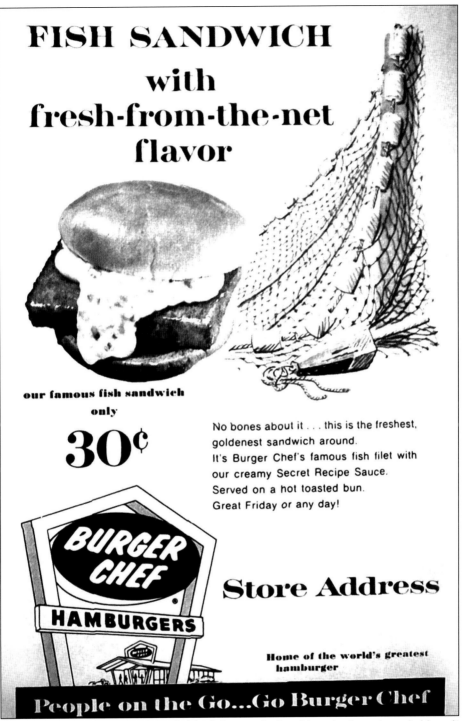

FISH SANDWICH
with
fresh-from-the-net
flavor

our famous fish sandwich

only

30¢

No bones about it . . . this is the freshest, goldenest sandwich around.
It's Burger Chef's famous fish filet with our creamy Secret Recipe Sauce.
Served on a hot toasted bun.
Great Friday or any day!

BURGER CHEF

HAMBURGERS

Store Address

Home of the world's greatest hamburger

People on the Go...Go Burger Chef

The Burger Chef fish sandwich probably did taste fresh, although there is probably a little hyperbole involved in this advertisement, which claims that it had "fresh-from-the-net flavor." The fish sandwich was very popular on Fridays, but Burger Chef made sure the customer was aware that it was "great Friday or any day." (Courtesy of Butch Schroeder.)

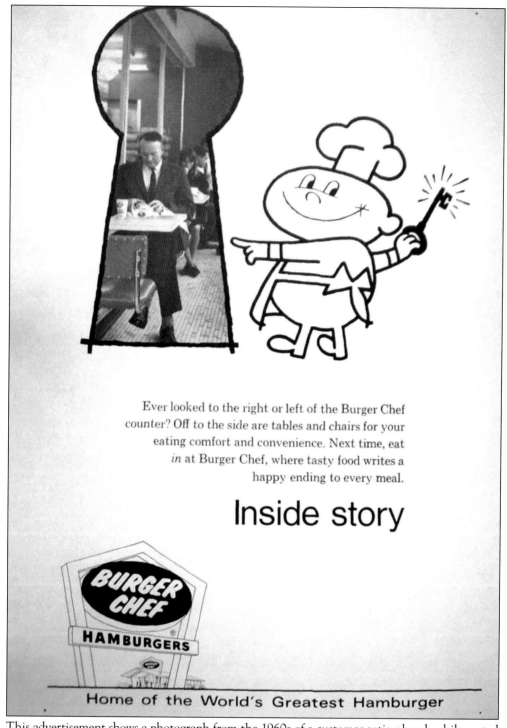

This advertisement shows a photograph from the 1960s of a customer eating lunch while seated at one of the small side booths at a Burger Chef. This is an example of the limited seating that was first installed in stores before larger dining-area additions were added in the late 1960s. (Courtesy of Butch Schroeder.)

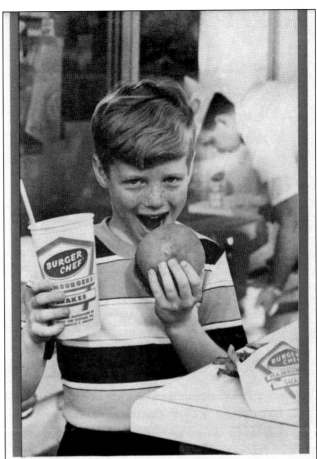

It's fun...
to go to Burger Chef!

It's the kind of "let's eat out" fun the whole family enjoys. It's going to a place where the only things really dressed up are the delicious hamburgers and fish sandwiches. It's being sure that the kids will get good, wholesome food that's easy on the budget. It's being served by friendly people in clean, modern surroundings. Just a few reasons why... it's fun to go to Burger Chef!

Over 500 Burger Chef Restaurants Coast to Coast

A satisfied little boy sitting at a table is just about to bite into a hamburger while holding a shake. Advertisements like this one from the 1960s were obviously targeted toward kids and families. The advertisement copy emphasizes that the whole family can come to Burger Chef without worrying about getting dressed up.

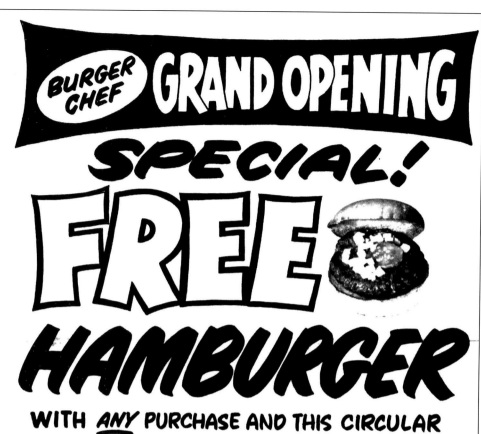

BURGER CHEF GRAND OPENING

SPECIAL!

FREE HAMBURGER

WITH _ANY_ PURCHASE AND THIS CIRCULAR

THIS OFFER LIMITED FROM THURS. JULY 27th
THRU TUESDAY, AUG. 1, 1967.

2319 WESTERN BRANCH BLVD.
(Rt. 17 By-Pass)
BY CHURCHLAND HIGH SCHOOL

When the Burger Chef located in Portsmouth, Virginia, had its grand opening in July 1967, it issued this flyer so that customers could present it at the store to receive a free hamburger with any other purchase.

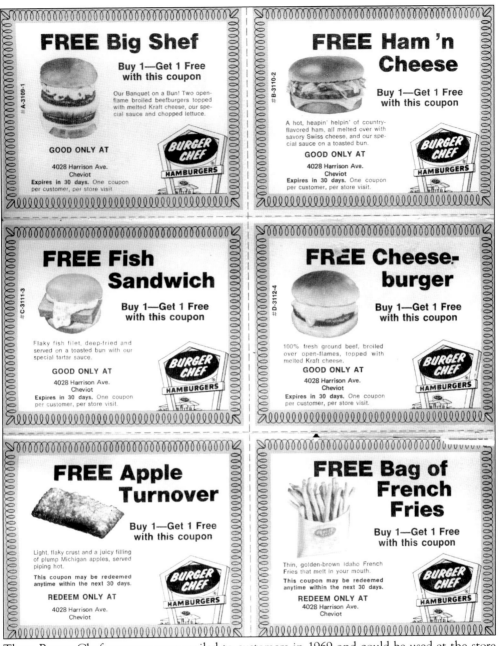

These Burger Chef coupons were mailed to customers in 1969 and could be used at the store located in Cheviot, Ohio. The hot ham and cheese was a sandwich that was test marketed in July 1969 at locations in several states.

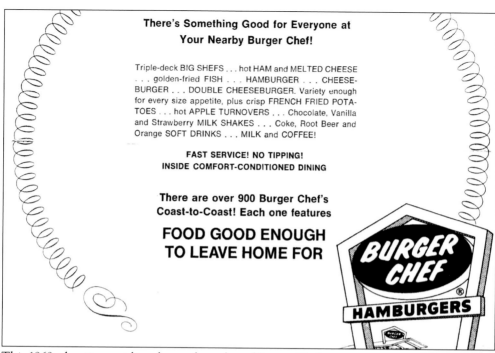

There's Something Good for Everyone at Your Nearby Burger Chef!

Triple-deck BIG SHEFS . . . hot HAM and MELTED CHEESE . . . golden-fried FISH . . . HAMBURGER . . . CHEESE-BURGER . . . DOUBLE CHEESEBURGER. Variety enough for every size appetite, plus crisp FRENCH FRIED POTA-TOES . . . hot APPLE TURNOVERS . . . Chocolate, Vanilla and Strawberry MILK SHAKES . . . Coke, Root Beer and Orange SOFT DRINKS . . . MILK and COFFEE!

FAST SERVICE! NO TIPPING!
INSIDE COMFORT-CONDITIONED DINING

There are over 900 Burger Chef's Coast-to-Coast! Each one features

FOOD GOOD ENOUGH TO LEAVE HOME FOR

This 1969 advertisement lists the total number of Burger Chef restaurants at over 900, a number that was reached that year. "Food good enough to leave home for" was a new advertising slogan that was introduced in March 1969.

The Burger Chef store at 2901 South General Bruce Drive was located in Temple, Texas. "We Treat You Right" was a slogan used by Burger Chef in the 1970s. This May 1972 advertisement still shows a 1960s street sign even though Burger Chef had changed the design by this time. Perhaps this location was still using an old sign and included it in the advertisement because it was familiar to area customers.

94

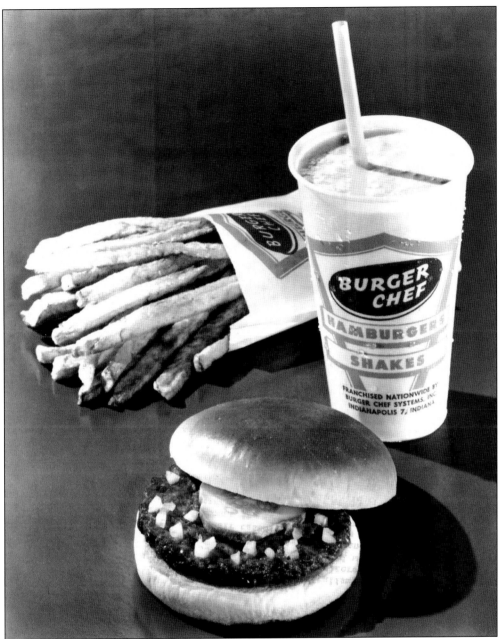

This 1960s photograph of the Triple Treat appeared frequently in Burger Chef advertising. One of the photograph's many uses was for the front of postcards that were mailed out to customers, entitling them to a free hamburger at certain locations. These postcards were mass mailed and sent to many homes. This photograph also appeared in franchising flyers sent out to prospective store owners. This very-detailed shot vividly shows the Burger Chef sign logo used on the shake cup and french fry sleeve at that time. (Courtesy of Frank P. Thomas Jr.)

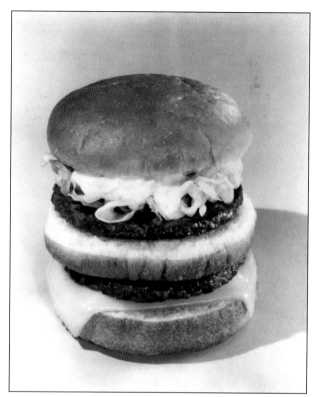

The Big Shef came out about three years before McDonald's introduced the Big Mac, its version of a double-decker hamburger. It was Frank P. Thomas Jr. who decided to change the spelling from *Chef* to *Shef*. He found that a lot of people mispronounced chef as chief, and he wanted to make sure people said the word correctly. Also, Big Shef was a name that could be copyrighted. (Courtesy of Frank P. Thomas Jr.)

Showing a close-up of an apple turnover, this photograph was used on the front of postcards sent out to customers. By bringing it to the store location listed on the back, a customer could receive a free apple turnover. (Courtesy of Frank P. Thomas Jr.)

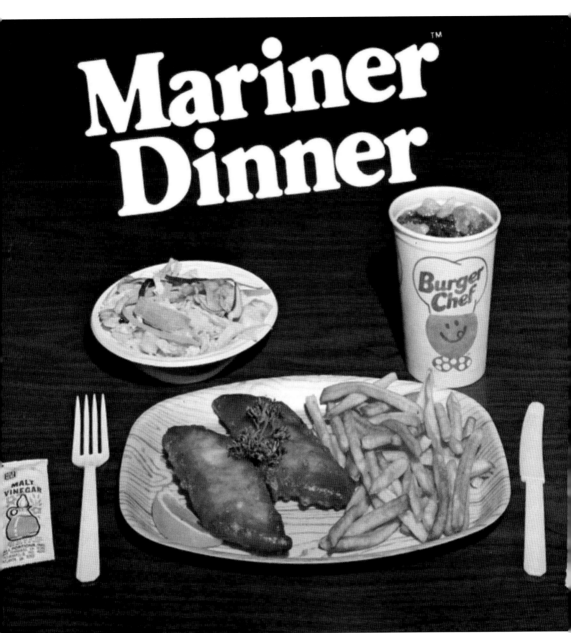

Mariner Dinner ™

The Mariner was a fish-and-chips dinner that was first test marketed by Burger Chef in 1974. The product was tested at 40 Burger Chef restaurants located in and around Providence, Rhode Island; Baton Rouge, Louisiana; Washington, D.C.; and Sturgis, Michigan, before the decision was made to add it to the menu in 1976. The Mariner was an extension of the platter concept first introduced with the Fun Meal in 1973 and the Rancher in 1975. The Fun Meal was a kid-sized meal marketed for children; the Mariner and the Rancher, consisting of a one-third-pound chopped steak patty, french fries, salad, and Texas toast, were created for adults. (Courtesy of Kyle Brown.)

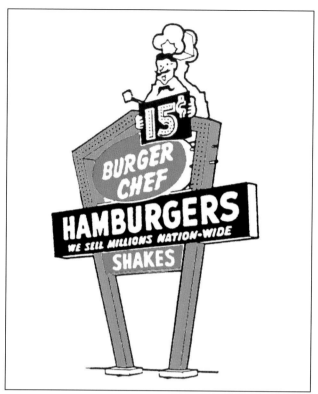

This was the original logo used by Burger Chef when it was founded in 1958. After a few years, the French chef was dropped from the sign. Burger Chef continued to use the sign minus the French chef as a logo throughout the 1960s. (Courtesy of Kyle Brown.)

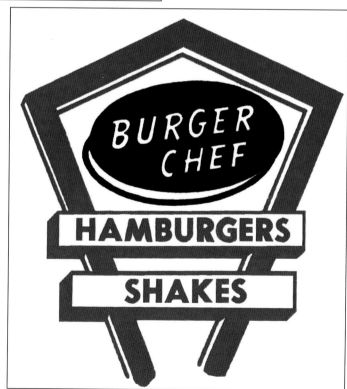

This sign logo was used during the 1960s, primarily on drink and shakes cups, french fry sleeves, and sandwich wrappers. (Courtesy of Kyle Brown.)

In the early 1960s, Burger Chef started using a little oval-headed chef as its mascot. In the mid-1960s, the little chef was slightly revised to appeal more to kids by making his face rounder and slightly more childlike. In 1968, his facial features were altered slightly to allow for more expression. Here are four poses of the chef from about 1968. (Courtesy of Kyle Brown.)

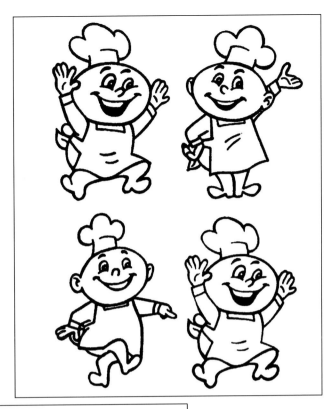

Around 1970, Burger Chef went to this logo, called the ball-and-flame. The flame represented the flame-broiled hamburgers cooked at Burger Chef. As this photograph shows, this logo was sometimes used in conjunction with a family graphic. It was used until about 1973, when it was replaced by the smiling chef logo. (Courtesy of Kyle Brown.)

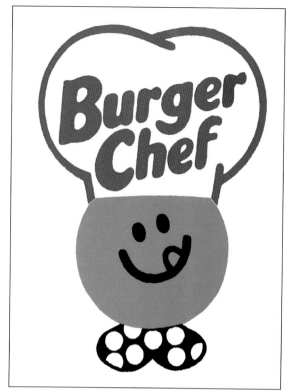

The smiling chef logo first appeared about 1973. It was a very distinctive logo, probably the one that people remember the most. This graphic was created to appeal mostly to kids. Burger Chef's main emphasis at this time was to gear the advertising toward children and families. (Courtesy of Kyle Brown.)

About 1978, changes in management at Burger Chef led to the creation of a new company logo. The chef's hat was a complete reversal from the smiling chef logo that preceded it. It was a simpler, more contemporary logo that was meant to symbolize quality. (Courtesy of Kyle Brown.)

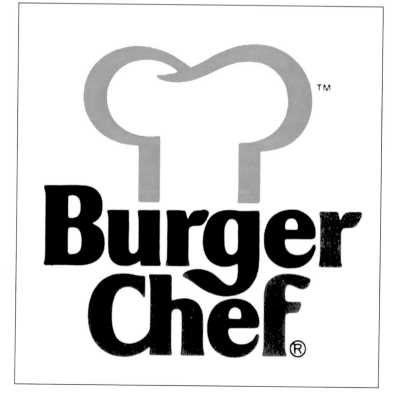

In 1972, Burger Chef and Jeff were introduced as the new company mascots. They became the most successful and well-remembered advertising icons ever created for Burger Chef. They were soon joined by a whole host of other Burger Chef cartoon characters. Burger Chef and Jeff appeared in numerous television commercials during the 1970s. (Courtesy of Paul Browning.)

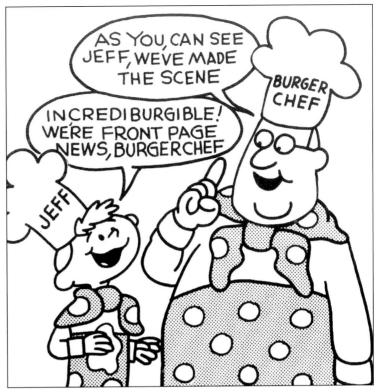

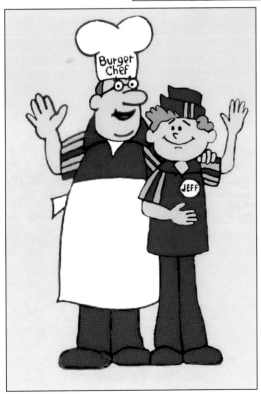

Voice-over actor Paul Winchell, who was most famous for providing the voice of Tigger in the Winnie the Pooh films, did the voice for Burger Chef in the television commercials. The voice of Jeff was probably voice-over actor Lionel Wilson, who did the voices for the *Tom Terrific* cartoons that appeared on the *Captain Kangaroo* show during the 1950s. (Courtesy of Kyle Brown.)

BURGER CHEF ADVERTISING AND PROMOTIONAL MATERIAL

Hard-hitting Burger Chef newspaper advertisements, commercials for radio and television, hand-bills, advertising specialties, etc. are made available on a year-'round basis. In addition, a national publicity program keeps the Burger Chef name constantly before the public.

A collage consisting of dozens of newspaper advertisements from the 1960s shows just how many different ideas and slogans were designed to sell Burger Chef's products. Ruben Advertising of Indianapolis was the agency that was responsible for Burger Chef's advertising from 1958 until about 1969. After Burger Chef was acquired by General Foods, New York–based McCann-Erickson took over as the restaurant's advertising agency, followed by another New York company, Ogilvy and Mather. It was Ogilvy and Mather that created Burger Chef and Jeff as well as other cartoon mascots like Count Fangburger, Burgerilla, and the Great Burgerini, to name a few.

Frischs Drive-In
Indianapolis, Indiana

Florida Restaurants, Inc.
Miami, Florida

Tops Sirloiner Restaurants
Arlington, Virginia

White Castle Systems
Columbus, Ohio

Hamburger Handout Drive-Ins
Los Angeles, California

Dari-Delite
Rock Island, Illinois

Smaks Drive-In
Greater Kansas City

Mr Quick Systems
Peoria, Illinois

Dutchland Dairy Stores
Milwaukee, Wisconsin

Dairy Belle Freeze, Inc.
S. San Francisco, California

Kwik Burger
Brooklyn, New York

Adventurers Inn
Yonkers, New York

Don & Bobs
Rochester, New York

Burdines
Miami, Florida

Dog N Suds
Champaign, Illinois

Frostop Root Beer
Tacoma, Washington

Beverly Drive-Ins
Columbus, Ohio

Biff Burger
Largo, Florida

Burger Chef Systems
Indianapolis, Indiana

Shoneys Big Boy
Huntsville, Alabama

Luau Chicken Drive-Ins, Inc
Norfolk, Virginia

Gleasons, Inc.
Rochester, New York

Butter Burger, Inc.
Wooster, Ohio

Burger Boy
Chattanooga, Tennessee

Donutville U.S.A.
Brooklyn, New York

Dairy Treat, Inc.
St. Louis, Missouri

Reindeer Frozen Custard
Washington, D. C.

Sea Lion Caves
Oregon State

Knott's Berry Farm
Buena Park, California

Arctic Circle, Inc.
Salt Lake City, Utah

Salad Bowl Restaurants
Bakersfield, California

Roscoe Whites Corral
Dallas, Texas

Bridgeman Dairy Stores
Duluth, Minn.

Frosted Scotchman, Inc.
Wheatridge, Colorado

Allens Drive-Ins
Greater Kansas City

why did they all choose

equipment?

Chain operations are choosey about equipment selection. They want complete dependability, high speed production, consistent quality of product, compactness of equipment and quickly available service wherever they have stores.

Sani-Serv, Sani-Shake and Sani-Broiler equipment meets every requirement for this highly competitive field. That's why more and more drive-in operators are choosing General Equipment to

supply their needs.

General Equipment offers added bonuses. They offer the most complete line in the industry so users can have *exactly* the equipment best for their operation. And, General Equipment offers a complete planning service to help you set up for most profitable operation.

Write today for General Equipment catalog and name of your nearest General Equipment Dealer.

LIFETIME GUARANTEE . . . *on the Evaporator of every Sani-Serv, Sani-Shake and Eze-Way model. Here, indeed, is complete assurance of Quality!*

GENERAL EQUIPMENT
MFG. & SALES, INC.
INDIANAPOLIS, INDIANA
1348 STADIUM DRIVE

Although General Equipment Company manufactured and supplied the restaurant equipment that went into each Burger Chef store, it continued to operate as a separate entity and sold equipment to a number of other restaurant chains. This advertisement lists some of the businesses that purchased equipment from General Equipment Company during the 1960s. Although most of the chains purchased shake or ice-cream machines, Kwik Burger, a small chain based in Brooklyn, New York, was one company that bought Sani-Broilers.

104

This 1960s General Equipment Company advertisement shows three of the many pieces of equipment it manufactured. At the top right is the Sani-Serv Model 426, which could dispense 14 gallons of soft ice cream and 32 gallons of milk shakes per hour. Below it is the Model B85-G Sani-Broiler, which could turn out 600 sandwiches per hour. To the left is the Sani-Broiler Model B42, a smaller, revolving broiler that could cook 300 sandwiches per hour. The Model 426 Sani-Serv was a versatile twin-head machine that could make either soft-serve ice cream or milk shakes.

RUSH-HOUR RELIABLES FROM GENERAL EQUIPMENT

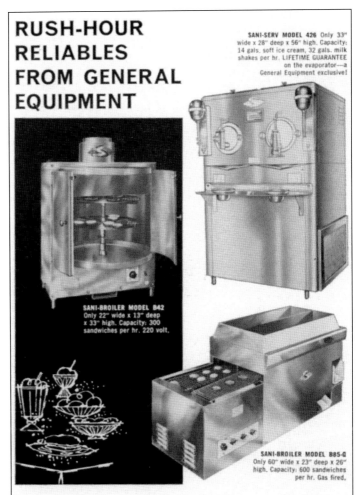

SANI-SERV MODEL 426 Only 33" wide x 28" deep x 56" high. Capacity: 14 gals. soft ice cream, 32 gals. milk shakes per hr. LIFETIME GUARANTEE on the evaporator—a General Equipment exclusive!

SANI-BROILER MODEL B42 Only 22" wide x 13" deep x 33" high. Capacity: 300 sandwiches per hr. 220 volt.

SANI-BROILER MODEL B85-G Only 60" wide x 23" deep x 26" high. Capacity: 600 sandwiches per hr. Gas fired.

When the heat's on, these babies never let you down. All our fast food service equipment is designed to take it!

We have, by far, the most complete line in the industry. Over 70 models, including the versatile Sani-Serv 426. It's a twin head combination. Dispenses soft ice cream from one head and milk shakes or malts from the other. Combine it with a Sani-Broiler—toasts buns and broils meat at the same time—and, even with inexperienced help, you can handle the biggest crowds.

Contact your local Sani-Serv/Sani-Broiler distributor, or write direct, for equipment catalog and free soft-serv dessert recipe booklet—"20 PROFITABLE WAYS TO SPICE YOUR DESSERT MENU."

SANI S SERV

Sani-Shake, Sani-Serv, Sani-Broiler—automated equipment for milk shakes, soft ice cream, sandwiches—manufactured by

GENERAL EQUIPMENT MFG. & SALES, INC. 1347 STADIUM DRIVE INDIANAPOLIS, INDIANA

Visit booth 2456, National Restaurant Show, Chicago, May 20-23

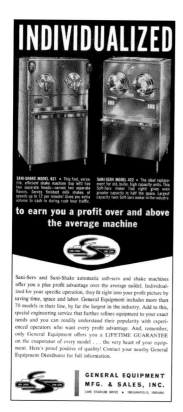

INDIVIDUALIZED

SANI-SHAKE MODEL 821 • This fast, versatile, efficient shake machine (top left) has two separate heads—serves two separate flavors. Serves finished milk shakes at speeds up to 12 per minute! Gives you extra volume to cash in during rush hour traffic.

SANI-SERV MODEL 422 • The ideal replacement for old, bulky, high capacity units. This Soft-Serv maker (top right) gives even greater capacity in half the space. Largest capacity twin Soft-Serv maker in the industry.

to earn you a profit over and above the average machine

Sani-Serv and Sani-Shake automatic soft-serv and shake machines offer you a plus profit advantage over the average model. Individualized for your specific operation, they fit right into your profit picture by saving time, space and labor. General Equipment includes more than 70 models in their line, by far the largest in the industry. Add to this, special engineering service that further refines equipment to your exact needs and you can readily understand their popularity with experienced operators who want every profit advantage. And, remember, only General Equipment offers you a LIFETIME GUARANTEE on the evaporator of every model . . . the very heart of your equipment. Here's proof positive of quality! Contact your nearby General Equipment Distributor for full information.

GENERAL EQUIPMENT MFG. & SALES, INC.
1349 STADIUM DRIVE • INDIANAPOLIS, INDIANA

As this 1960s advertisement states, General Equipment Company manufactured over 70 different models of Sani-Shake and Sani-Serv machines. The company produced models to meet the needs of any type of restaurant business, including its own Burger Chef operation. In addition to a lifetime warranty on the evaporator, the company was also willing to refine any of its machines to the exact specifications of the operator.

profitable dessert idea from Sani-Serv

Flaming Fruit Salad Sundae

Place 3 oz. of fruit salad or one ounce of 3 different fresh fruits in deep glass bowl. Cover fruit with generous portion of soft-serv. Place small peach half in center of soft-serv. Add four chocolate finger cookies and four cherries. Place cube of sugar that has been dipped in lemon extract on top of peach half and light. Serve flaming.

LET A VERSATILE Sani-Serv
ADD VARIETY AND PROFIT TO YOUR MENU

Ice cream desserts fresh from the freezer of a Sani-Serv are exceptionally delicious, and high profit items as well! With a compact Sani-Serv, that occupies only 2 square feet of space, you're all set to build a reputation for exotic desserts! The Sani-Serv Model 402 at left is a high capacity unit measuring only 21" wide x 28" deep x 56" high. Ideal for restaurants. Completely automatic, anyone can operate.

SANI-SERV MODEL 426 A twin head combination, dispensing soft ice cream from one head and delicious milk shakes or malts from the other. General Equipment offers over 70 models, one exactly right for your operation.

GET YOUR FREE DESSERT BOOK!

Your nearby General Equipment Distributor has your copy now of an interesting recipe book listing a wide variety of soft-serv desserts that can mean more money for you. Contact him today!

GENERAL EQUIPMENT MFG. & SALES, INC.
1349-51 STADIUM DRIVE • INDIANAPOLIS, INDIANA

One of the frequent strategies that General Equipment Company used in its advertisements was the inclusion of recipes to demonstrate the versatility of its machines. Listed here are the ingredients needed for the creation of a Flaming Fruit Salad Sundae, which was actually served flaming. General Equipment Company also sent out a free dessert book of recipes when requested.

Six

MEMORABILIA

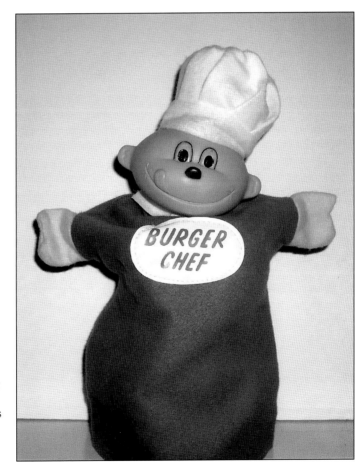

Burger Chef produced quite a number of toys and other store-related giveaways during its existence. One of the earlier items is this Burger Chef hand puppet from the 1960s. The puppet has a felt body and chef's hat, while the head is made of rubber.

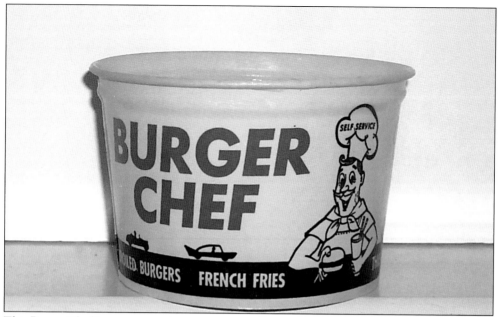

This Burger Chef ice-cream cup is a mystery item. Burger Chef founders Frank P. Thomas Jr. and Donald J. Thomas could not identify this as a cup that was used in their restaurants. However, the French chef on the front label matches the one that was used by Burger Chef for some of its advertising. Frank P. Thomas Jr. speculated that the cup could have been a prototype made by a cup company that was sent to Burger Chef for consideration.

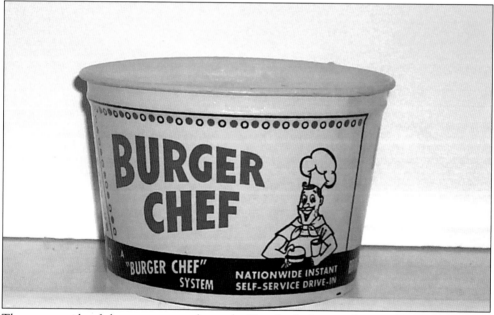

The reverse side of the mystery cup shows the French chef again along with some additional lettering. One other possible explanation for the existence of the cup could be that it has some connection to the Burger Chef demonstration stores that opened in 1957. The "A 'Burger Chef' System" slogan and the French chef on the cup match what was included on the signs used for the demonstration stores.

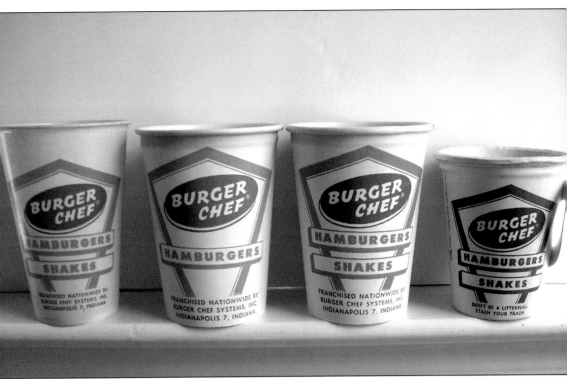

This photograph shows a line-up of Burger Chef cups from the 1960s. The cup on the left is a waxed drink cup that was used for sodas. The two cups in the middle are insulated coffee cups with slightly different labels. The cup on the right is a smaller coffee cup with a handle. The lid on the top of the cup is original.

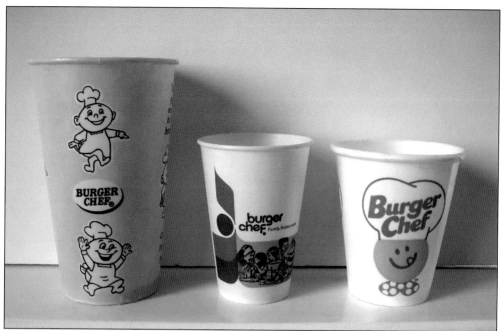

Here are three waxed drink cups that show a progression of logos used by Burger Chef. The left cup with images of the little chef was used from about 1968 to 1970. The middle cup shows the ball-and-flame logo that was used from about 1970 to 1973. The cup on the right has the smiling chef figure that was used until about 1977.

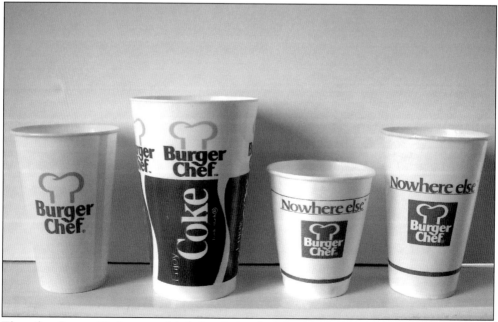

These four Burger Chef cups are labeled with the chef's hat, the last logo that was used by Burger Chef. The two on the left are from the late 1970s, and the two on the right with the "Nowhere else" slogan are probably from the early 1980s.

The three pin-back buttons shown in this photograph are all from the 1960s. The button on the left is probably from about 1967, the year when most fast-food chains raised the price of their hamburgers. Burger Chef was one of the last fast-food chains to change its price, and that made it the number one 15¢-hamburger chain for a few months.

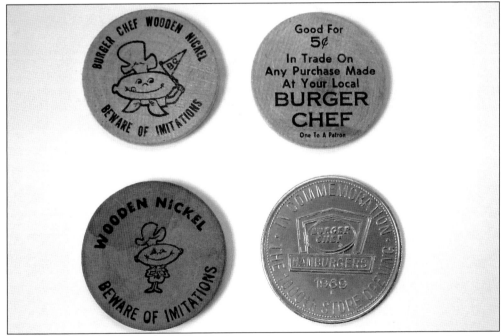

This photograph shows three Burger Chef coins that were given out at restaurants. At the top is the front and back of a wooden nickel. The wooden nickel on the bottom left has a slightly different front. Wooden nickels were also thrown from Burger Chef floats to crowds during parades. The coin on the bottom right commemorates the opening of the 1,000th Burger Chef store in 1969.

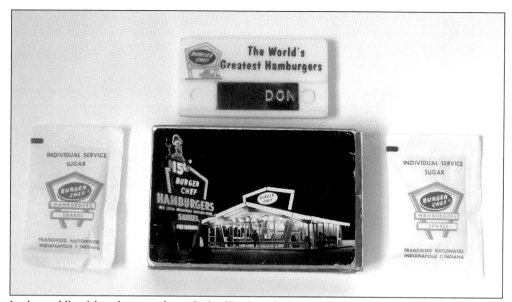

In the middle of this photograph is a deck of Burger Chef playing cards flanked by two sugar packets and a name tag. All of the items are from the 1960s. The playing cards were a promotional item that was either sold or given away. The night photograph on the playing cards was a frequently used shot that appeared on a lot of Burger Chef material during the 1960s.

These two plastic Burger Chef car trays were sold at stores as a promotional item during the early 1960s. They were individual trays that were designed to fit into the doorsills of cars to support food and a drink, and they were available in at least two different colors.

A number of Burger Chef promotional items were given out to managers and executives at company meetings and conventions during the year. That was the case with this rocks glass that was given to employees at a 1960s convention. This particular glass was a gift to the author from Burger Chef founder Frank P. Thomas Jr.

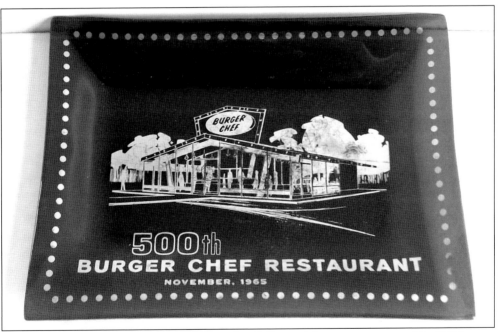

The Burger Chef chain grew rapidly during the 1960s, and the company opened its 500th store in November 1965. To commemorate the event, glass dishes like this one were issued. The lettering and the image of the Burger Chef restaurant was done in gold paint, which contrasts nicely with the charcoal-colored glass of the dish.

Burger Chef shirt patches like these two were worn by store employees during the 1960s. The patch on the left is older and was the first one used by the company. The patch on the right was worn during the late 1960s. The Burger Chef coin purse pictured below was another promotional item.

At the top of this photograph are two printer blocks that were used to make the oval Burger Chef sign logo in the 1960s. Below them are an ice pick and a matching bottle opener from the Burger Chef stores located in the Wisconsin towns of Waukesha, Hales Corners, Greenfield, Oconomowoc, and Janesville.

This assortment of Burger Chef memorabilia includes a number of items from the 1960s. In the top row, from left to right, are a money clip, a tape measure, an ice scraper, a key chain, and another tape measure. In the bottom row are two Burger Chef pencils, which were given away to students as part of a back-to-school promotion in the fall.

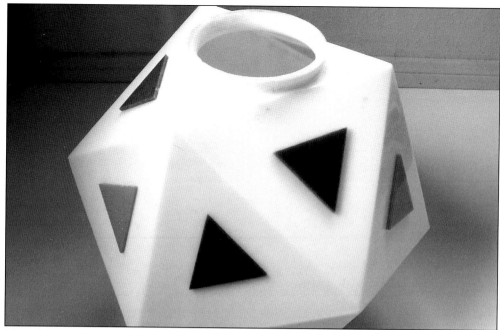

This photograph shows a Burger Chef light globe, which was used in stores until the early 1970s. Plastic turquoise and orange triangles were glued to each face of the 20-sided figure, which is called an icosahedron. The angular light globes emulated the angles used for the roof arch and the buildings, which is probably why Burger Chef chose such an unusual shape.

The logo used on these hamburger sacks was the same one used on drink cups and french fry containers. These sacks were used in the 1960s and are just big enough to hold a hamburger and fries, which makes them pretty small by today's standards.

Seven

LIFE AFTER BURGER CHEF

The Mine Steak House was a family steak concept that Donald J. Thomas developed after Burger Chef. He opened two restaurants in the suburbs of St. Louis during the 1970s. Due to the tough economic conditions in the United States at that time, Thomas was unable to run the Mine restaurants successfully, and he sold them after about four years of operation. (Courtesy of Donald Thomas Jr.)

This photograph shows one of Donald J. Thomas's Mine Steak House restaurants. The large rocks and timbers on the exterior give the building a rustic look that is combined with the contemporary-style sloping roof. The mine-shaped sign and the little coal car reinforce the theme used by the restaurant. (Courtesy of Donald Thomas Jr.)

FedPak Systems was another company founded by Thomas after Burger Chef. He designed and patented a machine that could dispense soft-serve ice cream, frozen yogurt, and other confections to customers. In this photograph, an unidentified employee is working on the FedPak assembly line in Indianapolis around 1991. Thomas eventually sold the company in the 1990s. (Courtesy of Donald Thomas Jr.)

In 1969, Frank P. Thomas Jr. bought and restored the State Life building in Indianapolis and moved the Taylor Foundation, a project he started to assist children with vision problems, to the fifth floor of the building. From left to right, this photograph shows Indianapolis mayor (later senator) Richard Lugar; Frank P. Thomas Jr.; his wife, Jill Thomas; and Indiana governor Edgar Whitcomb at a ribbon-cutting ceremony following the restoration. (Courtesy of Frank P. Thomas Jr.)

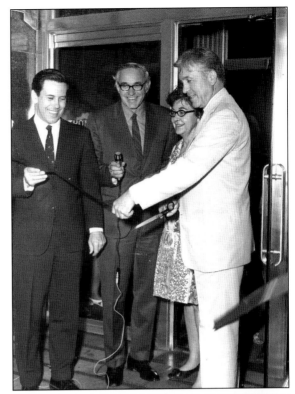

In 1980, Frank P. Thomas Jr. cofounded a company called Precise Flight to build speed brakes for light aircraft. He eventually became its sole owner and then sold the company. After living in California, he and his wife, Jill, relocated to Taos, New Mexico. He is pictured here on the right standing next to the author in the backyard of his Taos home in June 2003.

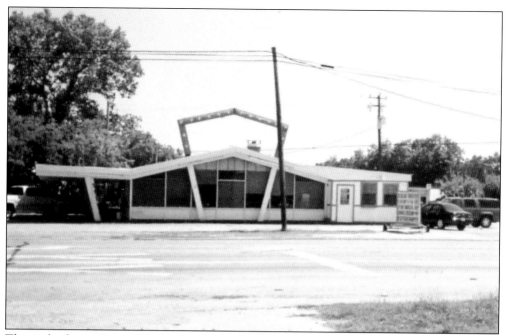

This is the former Burger Chef restaurant located in La Marque, Texas. It is currently operating as a seafood restaurant. This 1960s building still retains the roof arch, which has some of the original plastic fascia intact. The area attached to the side was not part of the original design and is a later addition.

The sign at the former La Marque, Texas, Burger Chef is still fairly intact, although the French chef that was once attached to the top has been removed. The raised pedestal of this sign is unusually high. Perhaps it was necessary to raise the height of the sign in order for it to be seen clearly from the road.

The former Galveston, Texas, Burger Chef is now a popular Cajun seafood restaurant. The front arch is still present, although the top of it is partially obscured by the restaurant sign. The exterior of the building has been remodeled, and a large side extension has been added, which is visible on the right side. No trace of the original 1960s street sign still exists.

This shot shows the roof arch of the former Galveston, Texas, Burger Chef from the rear. This view clearly shows the restaurant's current sign attached to the front of the old arch. The electrical connections of the original sign are working and are still being used. None of the original plastic fascia still remains on the side of the building.

The former Burger Chef in this photograph is located in Warrensburg, Missouri. The top half of the street sign has been removed and the lower section remodeled. The building still has most of the original front glass and fascia intact, and the original light globes can be seen hanging inside. The roof arch has been removed. (Courtesy of Donald P. Thomas Jr.)

Now being used as a nightclub, this former Burger Chef located at 2728 South Richey Street in Houston, Texas, has had almost every trace of its original Burger Chef architecture removed. However, the prominent roof arch is an unmistakable feature that reveals the past identity of the building. No evidence of the original 1960s street sign remains at this site.

This former Burger Chef in Houston, Texas, still has the original roof arch and part of the Burger Chef sign attached. The brick portion of the building was an extension that was added when the building was remodeled and enlarged. The paint sprayed over the exterior completely obscures all of the original colors of the building. Now abandoned, this location was once home to a food-manufacturing company.

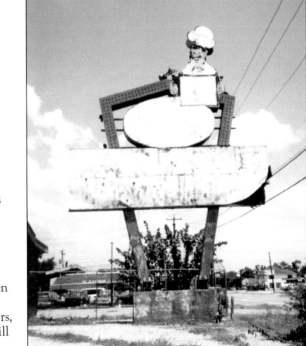

The original street sign still remains at the front of this former Houston, Texas, Burger Chef. The porcelain coated steel French chef sign is still attached at the top, although the other signs have been covered over. Some damage to the sign can be seen on the right side, where a portion is bent forward. Even after over 40 years, some of the original orange paint still remains on the sign.

This building located at 749 Washington Street in Middletown, Connecticut, is a former Burger Chef from the late 1960s or early 1970s. It is a great example of a surviving Cosmo II–style store that is still in good condition. At the time of this 2003 photograph, it was a hair salon, but in 2009, it is being used by a rental car company.

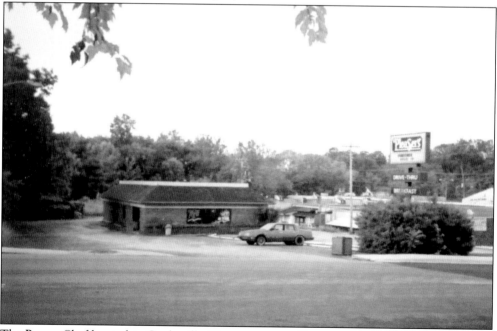

The Burger Chef located in Cookeville, Tennessee, was able to continue operating as a Burger Chef for 14 years following the sale of Burger Chef to Hardee's in 1982. When the terms of its lease expired in 1996, the restaurant closed and reopened as a Pleasers restaurant. By the time this photograph was taken in 2003, the restaurant was no longer in business.

Schroeder's Drive-in is a former Burger Chef located in Danville, Illinois. It was opened as Burger Chef store No. 57 in 1960 by Hank Schroeder. Located at 432 North Gilbert Street, the restaurant was the highest-grossing store in the Burger Chef system for over 10 years. It stayed in operation as a Burger Chef until 1992.

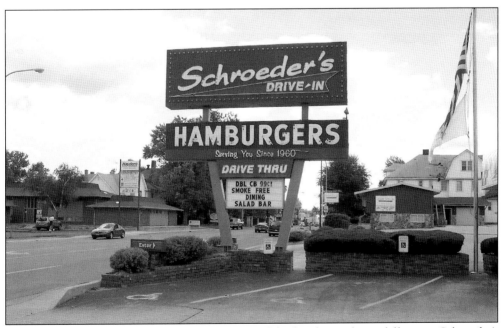

The 1960s Burger Chef sign has been altered, one of the few things that is different at Schroeder's Drive-in. The store and the menu have changed very little over the years, giving patrons the opportunity to enjoy a meal in a very Burger Chef–like atmosphere. The store has an impressive collection of Burger Chef memorabilia on display inside.

At this former Burger Chef located at 916 Sunset Road Southwest in Albuquerque, New Mexico, part of the 1960s street sign still remains. The restaurant building still exists as well. It is mostly obscured by the large building in the middle of the photograph, but a portion of it can be seen behind the car parked in the foreground.

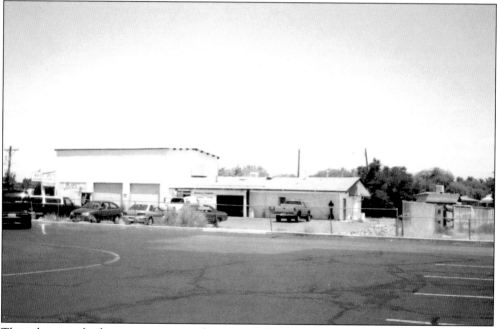

This photograph shows a more complete view of the former Burger Chef store located at 916 Sunset Road Southwest in Albuquerque, New Mexico. The original building is the one with the open garage door located just to the right of the larger structure, which occupies the space that was once the parking lot. The site is currently being used to house a plumbing company.

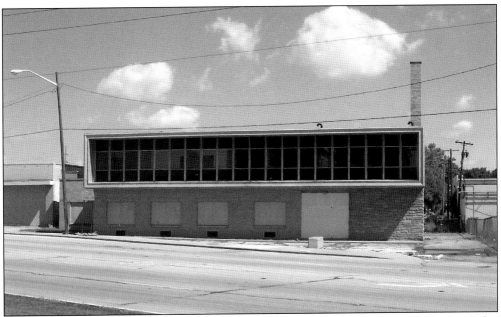

The former Burger Chef headquarters located at 1348 West Sixteenth Street is shown in this photograph taken in 2004. The concrete base that once anchored a street sign by the main doors still remains. Before the street was widened, a small parking lot existed in the front. This building has since been demolished.

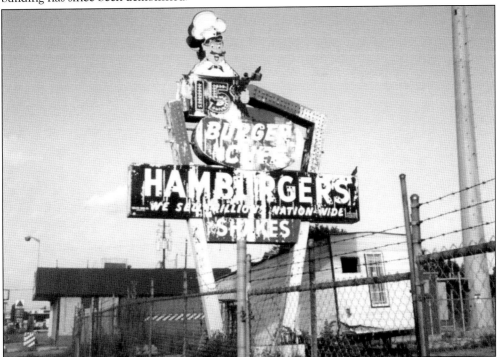

Not all Burger Chef street signs from the 1960s have been altered or removed. This fairly intact sign has withstood the ravages of the weather for over 40 years and still stands at its original location in Houston, Texas. These enormous signs were almost 30 feet high and nearly 20 feet wide.

DISCOVER THOUSANDS OF LOCAL HISTORY BOOKS
FEATURING MILLIONS OF VINTAGE IMAGES

Arcadia Publishing, the leading local history publisher in the United States, is committed to making history accessible and meaningful through publishing books that celebrate and preserve the heritage of America's people and places.

Find more books like this at
www.arcadiapublishing.com

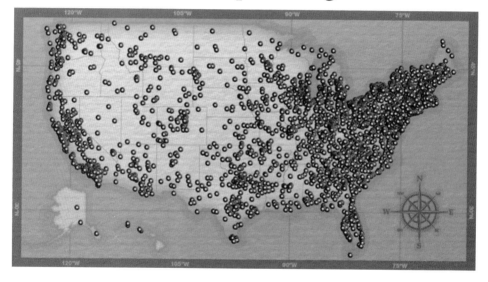

Search for your hometown history, your old stomping grounds, and even your favorite sports team.

Consistent with our mission to preserve history on a local level, this book was printed in South Carolina on American-made paper and manufactured entirely in the United States. Products carrying the accredited Forest Stewardship Council (FSC) label are printed on 100 percent FSC-certified paper.

MADE IN THE USA